D0860800

7th COUSINS

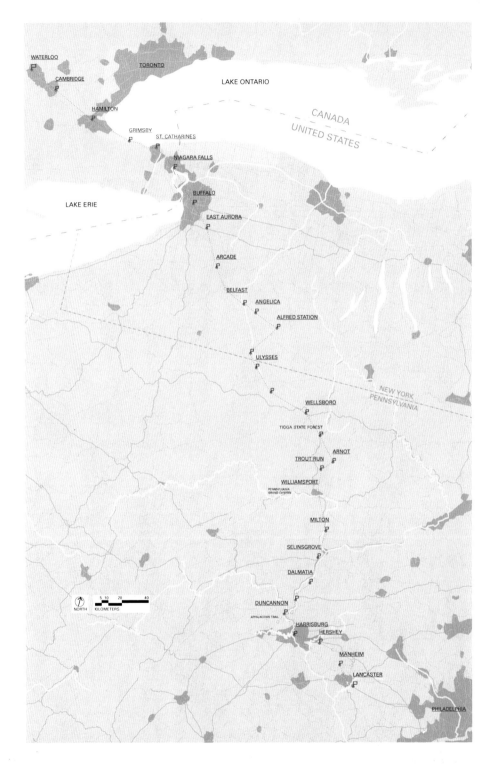

7th COUSINS

An Automythography

Erin Brubacher and Christine Brubaker

Book*hug Press

TORONTO

FIRST EDITION

copyright © 2019 by Erin Brubacher and Christine Brubaker
text on pages 112–115 copyright © 2019 by Erum Khan
Endnotes, or, A Talkback on pages 170–174 © 2019 by Christopher Stanton and Andrea Nann

Journey Gesture photographs on pages 44–51 by Samuel Choisy, choreographed by
Andrea Nann; production photographs on page 78 and page 99 by Sophia Wolfe, taken
at Pushoff; all other photographs by Erin Brubacher. Used with permission.

ALL RIGHTS RESERVED

No part of this publication may be reproduced or transmitted in any form or by any
means, electronic or mechanical, including photocopying, recording, or any information
storage or retrieval system, without permission in writing from the publisher.

Library and Archives Canada Cataloguing in Publication

Title: 7th cousins : an automythography / Erin Brubacher and Christine Brubaker.
Other titles: Seventh cousins
Names: Brubacher, Erin, 1979– author. | Brubaker, Christine, author.
Identifiers: Canadiana (print) 20190199466 | Canadiana (ebook) 20190199474 | ISBN
 9781771665469 (softcover) | ISBN 9781771665476 (HTML) | ISBN 9781771665483 (PDF) |
 ISBN 9781771665490 (Kindle)
Subjects: LCSH: Brubacher, Erin, 1979-—Travel—Northeastern States. | LCSH: Brubaker,
 Christine—Travel—Northeastern States. | LCSH: Women performance artists—Travel—
 Northeastern States. | LCSH: Women performance artists—Canada—Biography. |
 LCSH: Northeastern States—Description and travel. | LCSH: Hiking—Northeastern
 States. | LCSH: Hospitality—Northeastern States.
Classification: LCC F106 .B78 2019 | DDC 917.404/44—dc23

Printed in Canada

The production of this book was made possible through the generous assistance of the
Canada Council for the Arts and the Ontario Arts Council. Book*hug Press also
acknowledges the support of the Government of Canada through the Canada Book
Fund and the Government of Ontario through the Ontario Book Publishing Tax Credit
and the Ontario Book Fund.

Book*hug Press acknowledges that the land on which we operate is the traditional
territory of many nations, including the Mississaugas of the Credit, the Anishnabeg,
the Chippewa, the Haudenosaunee and the Wendat peoples. We recognize the enduring
presence of many diverse First Nations, Inuit and Métis peoples and are grateful for
the opportunity to meet and work on this territory.

CONTENTS

PERFORMANCE COLLABORATORS LEGEND

CO-CREATORS/ PERFORMERS:

EB Erin Brubacher
CB Christine Brubaker

DIRECTORS:

AN Andrea Nann, director/choreographer
CS Christopher Stanton, director/dramaturge

PRODUCTION TEAM:

KH Kaitlin Hickey, production designer
EK Erum Khan, production assistant

Our collaborators' voices appear in this book in a few ways.
Most notably, AN crafted many of the stage directions within and
CS wrote most of the editorial endnotes you'll find at the
conclusion of the performance text. This book would not be
what or how it is without our collaborators. We know this and
want you to know it too. —EB/CB

HISTORY OF FIRST PERFORMANCES

December 2014 *Brubach/ker Family Dinner*, Christine Brubaker's Home, Toronto

July 2015 *The Walk*, Pennsylvania–New York–Ontario

July 2015 *Walk With Us*, a site specific invitation, with audience-participants across North America and Europe

August 2015 *The Unpacking*, Summerworks Performance Festival, Toronto

July 2016 *7th Cousins* Workshop Performance, The Theatre Centre, Toronto

June 2017 *7th Cousins*, The Royal Canadian Legion, Toronto; Presented by Nightwood Theatre

August 2017 Excerpt of *7th Cousins*, The Brubacher Family 300th-Year Anniversary, Millersville, Pennsylvania

August 2017 *The Unpacking*, Summerworks Performance Festival, Toronto

September 2017 *7th Cousins*, St. Matthews United Church, Toronto; Presented by Nightwood Theatre

December 2017 *7th Cousins*, The Emmet Ray Bar, Toronto; Presented by Nightwood Theatre

June 2018 *7th Cousins*, The Ismaili Centre, Toronto; Presented by Nightwood Theatre

June 2018 *7th Cousins*, Conrad Grebel Chapel, Waterloo; Presented by Green Light Arts

February 2019 Excerpt of *7th Cousins*, The Russian Hall, Vancouver; Presented by Theatre Replacement at PushOFF

From July 7 to August 6, 2015, we walked seven hundred kilometres, from Pennsylvania to Ontario. A stranger asked if we were walking to learn how to be together. This was certainly part of it. —CB and EB

Dear reader,

Welcome.

This is a book about a walk. It is also a book documenting a performance about a walk. Some of our collaborators have commented in endnotes in this book. Reading these might feel something like the chaos and magic of being in our rehearsal hall—you'll have some of the process in your hands.

At the beginning of every performance, we greet the audience and offer them something to eat and drink. In a bar, beer. In a church, homemade pie. In an Ismaili centre, masala chai. We try to offer something that suits the place where we are performing. So now, reader, we'd like to invite you to fix yourself something that might bring you pleasure or comfort in this moment, wherever you are. A glass of water, a stiff drink, some leftovers, a bowl of pretzels, a cup of tea, an espresso…When you're ready, come back and reopen the book where you left off:

Here.

On the next pages, you will see a collection of images from our seven-hundred-kilometre walk. Pick one. Hold it in your mind.

Welcome.

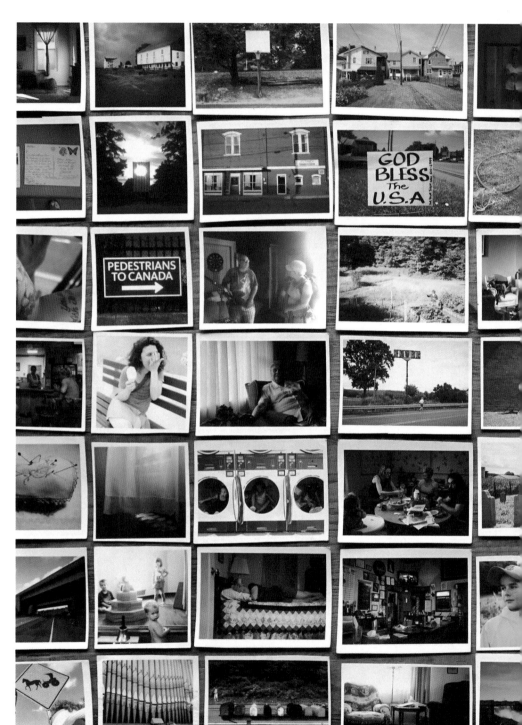

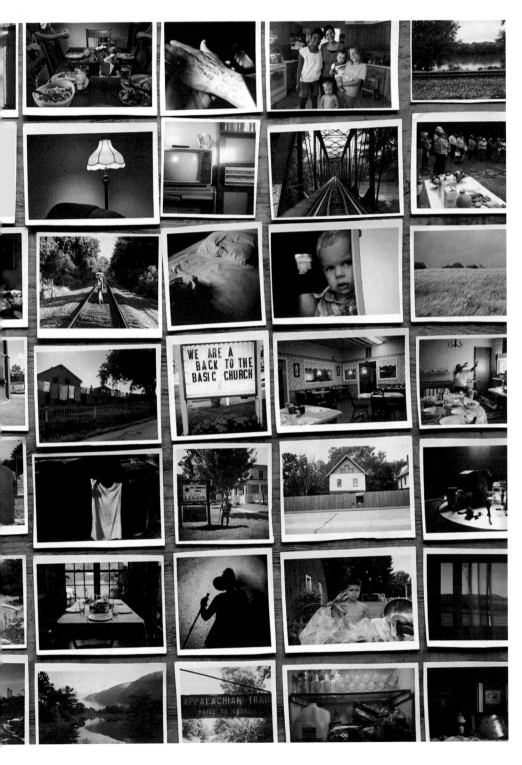

EB and CB welcome and greet audience members as they enter. They offer each person something: a "hosting" gesture—as one might do when an invited guest first enters a home.

CB and EB invite the audience to look through seven hundred photos— spread out on tables around the room—from their thirty-two-day journey on foot. Each guest is invited to select a photo they will keep with them during the performance. After a time, the audience members take their seats, which are set up in a circle.

There are two kilometre markers, like highway signs, on tall stanchions, that read "0 km" and "700 km." They are positioned at either side of an opening in the audience circle. Also in the room: a document camera, two projection surfaces, two sets of headphones attached to cellphones, two speakers, two stacks of postcards, two stacks of kilometre markers, two sets of name tags, and more empty metal stanchions of varying heights, positioned around and beyond the perimeter of the audience circle.[1] EB and CB stand, side by side, between the markers for 0 kilometres and 700 kilometres.

CB

Okay. Well.[2] In July 2015, Erin and I walked seven hundred kilometres.

EB

We walked from Lancaster, Pennsylvania, to Waterloo, Ontario, tracing the migration of our Mennonite ancestors.

CB

It took us thirty-two days.

EB

We took three days off.

CB

People asked us why we were walking. I asked myself that all the time.

EB

Someone asked me if we were walking to learn how to work together. I liked that.

CB

We stayed with people we found through a paper directory called *Mennonite Your Way*—it's like Mennonite couch-surfing.

CB picks up a copy of the directory and shows it around.

EB

It only exists like that, on paper. You can't get it online. I called most of these people. Some of them don't even have email. Or never check. Although I did get one email reply a full year after the walk.[3]
 Every meal with people...

CB

New people all the time...

EB and CB glance at each other[4] as they sit, in simple matching kitchen-table chairs, and perform the first five Table Gestures. The Table Gestures are a sequence of twenty-six physical actions paired with the names of individuals, spoken aloud, who hosted CB and EB along the walk.[5]

EB/CB

Carolyn and Ralph
Linda
Anne
Hannah
Patricia and Elton—

Shift

EB

Who has a photo they want us to remember?

Audience members volunteer their photos, which they've chosen from among the seven hundred photos of the walk. EB collects three of them.[6]

For the Photo Game, both CB and EB have to "remember" photos through spontaneous improvisation. They use a document camera to project the images, so that everyone in the room sees each image at the same time.

EB

Christine has two minutes to remember these three photos. And, while I might very much like to, I'm not allowed to say a single word about it.

(To CB) Don't look yet.[7]

EB hands the three images over to CB and sets a timer for two minutes. CB sits at the document camera, where she can control the display of each image, deciding for herself how much of the two minutes she wants to speak about each photo, while EB acts as timekeeper, sitting in another part of the room, watching.

(The improvisation below is transcribed from a performance on Saturday, June 9, 2018, at Conrad Grebel College in Waterloo, Ontario.)

EB

Two minutes, three photos. Don't look yet...Ready? Go!

CB

All right...Oh!...Okay...Uh...great. Great...this is a...place...

um...It's, uh, it's a home in the middle of a tiny town which we totally got lost trying to find, and Google totally let us down—this town, which is really about four houses, as far as we could tell. And this is the home built by a couple we stayed with, and in this house...Well, his wife had basically built it, and in the house, it was *full* of tchotchkes from everywhere—

EB
One minute,
thirty seconds.

CB
—as she was, basically, like this crazy online shopper. She would buy things, stuff from all over North America, and so everywhere you turned, there was like...uh...a collection of antique spices...or, uh...or a bunny area...or dog porcelain things...It was, like, packed! It was this kinda crazy, strange museum to collectordom...and even their fridge was filled with things she would collect, like water bottles, like tons! And ketchups—

EB
One minute!

CB
Okay...uh...
Wow, who picked
this photo?
Yeah...this is...
this is Erin and I
in various states of
undress at the end
of the day. And

we...yeah...we are drinking something that you'll hear about later...
we call "clandestine beers." We basically just walked one of our
longest days...and I think we had walked about ten hours and we
were going to the town of Selingsgrove, but on the way there, we had
stopped in this other little town...called Halifax, yeah...and Erin,
who loves beer, bought these beers, and we carried them for hours in
our backpacks, and by the time we got to Selingsgrove, they were
warm—

EB
Thirty seconds!

CB
—so when we got to our host's place, I begged them for ice, telling
them it was for our feet, but in fact—yeah...We put the ice in our
beers and we drank them...

CB
Okay. This! This...is actually a really beautiful place called the
Pennsylvania Grand Canyon. And this is at the very top of a...the

canyon, in a campground where we stayed that was completely abandoned. No one was in there. And we had forged a river the day before and we had started hiking, and we were both kind of nervous 'cause people had talked about bears, and sure enough, as we're hiking along we see three baby bears on one side of us, and then we're looking around for the mother and we had no idea where she was, and anyway, Erin had been trying to get me to sing the whole trip...and all of a sudden I actually burst into song...

The timer goes off. EB's turn.

CB

Who has a photo? Who has a photo they want Erin to remember?

EB and CB switch positions and the game is repeated. Some audience members volunteer their photos, and CB collects three. (The improvisation below is transcribed from a performance on Sunday, September 24, 2017, at St. Matthew's United Church in Toronto.)

CB

Erin has two minutes to remember these three photographs...

EB

(To CB) And you're not allowed to say anything.

CB hands the images over to EB and sets the timer for two minutes. EB sits at the document camera, where she can control the display of each image, deciding for herself how much of the two minutes she wants to speak about each photo, while CB acts as timekeeper, sitting in another part of the room, watching.

CB

Are you ready? Two minutes…Go!

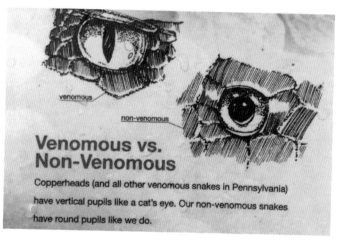

EB

Ohhhhhh, oh, oh, oh, okay! So, this sign, I think it's hilarious because it's a sign that tells you which kinds of snakes are venomous and which are not, and if you'll notice, the venomous kind, the dangerous kind, it looks mean. And the one that's not dangerous, it's really cute and friendly-eyed…and so, I just thought this was very amusing, but this sign, I took this picture of this sign, in the Pennsylvania Grand Canyon. And, uh, Christine and I crossed the Pennsylvania Grand Canyon, uh…It was the most adventurous day

of our journey because we went, uh, we crossed a river and it was about, sort of, this deep, and we had our pack on, and, uh, we had one walking pole each because we only invested in one pair...and, uh, I let Christine go first, and she fell in—

CB
One minute!

EB
—and then, uh, I was like: okay, I see where the danger spot is, I'm just gonna mosey along...And I didn't fall in, so...that was satisfying for me. But, uh...one side of the...Oh dear, okay, we'll come back to it if we have time.

EB
So, this is...I don't care about this picture so I'm just going to rush over it. It's the light. It's just the light. I'm allergic to dogs so I can't really hang out with them, so it was not about the dog at all, it was about the light.

EB

Uh…this picture speaks for itself. The sign at the bottom right there says, "Democrats, progressives, communists: all the same."

CB

Thirty seconds!

EB

We encountered this a lot. It was disturbing. So I'm just going to go back to talking about The Pennsylvania Grand Canyon. So . . . the Pennsylvania Grand Canyon…uhhhh…Oh! We saw bears! First, we saw a bear and then we saw its mother. And it was the only time I successfully got Christine to sing with me on the road because we

had to sing at the top of our lungs because we were so scared of the bears, and I believe that we sang the entire soundtrack to the musical *The Sound of Music*.[8]

CB

Time!

The timer goes off.

EB

The Story About the Brick.

CB

Okay. Well. When Erin and I were in the early stages of working together, we learned about these bus tours to Europe. There are these Mennonites, pacifists who many years earlier had fled Europe to the United States to escape religious persecution. And now there are hundreds of Mennonites who go on these bus tours. They are going in search of the villages where they had lived—where they were from. And there was one man on this particular bus tour who was really quite obsessed with finding his original village—finding out *exactly* where his house was. So as his bus tour found its way to a little village in the Netherlands, or Germany, or wherever it was, the tour guide, presumably sensing this man's need, said, "Well, you know there's something up on that hill—ruins up on that hill. Is that maybe where your house was?" And the man, who had not been there for many, many years, said, "Yes! That's probably where it was." So they got off the bus and walked together up the hill, and when they got to the top, the guide, she knelt down in front of this

huge pile of rubble, picked up a brick, held it out to the man, and said, "Maybe this is a brick from your house?" And the man said, "Yes! This is a brick from my house!" So. The guide—she's not bullshitting him. She's creating something for him that he needed.

EB
They created it together.[9]

CB
The Story About the House.

EB
Okay. Well. There is a museum called the Brubacher House in Waterloo, Ontario. It's a heritage house, built in 1850. Now, at some point in the late 1960s, the house was gutted by fire. Unrecognizable. A record of history gone. And that's the purpose of these places: to show us the *truth* of what things were like. Well, what happened was, after that, a master Mennonite craftsman and a group of elderly Mennonite farmers reconstructed the thing—*from memory*. They said, "This is how high the ceiling was. Here there was a table by the window. This is where they would have placed the wash basin. This is where Sunday visitors hung their hats. And this is how many pegs they hung on."[10] But they didn't *really know* how many pegs there were.

CB
We're not looking to *replicate*. We can't.

EB

And that's not what we're interested in. We weren't trying to re-enact the walk of our ancestors. We make no claims that we're conveying historical accuracy. Just that there is a sense of truth.

CB

Like the man on the bus tour: it could have been his house—why not? Does it matter? If he decided to take the brick away and say, "That tour guide took me to my house..."

EB

If he really wanted to know if it was a fact, he would have probed further and verified. Would *you* take for certain if someone said, "Maybe this is a brick from your house"? Would you say, "Yes! It is a brick from my house!" You wouldn't do that *unless* that's what you wanted to believe.

CB

When people said to Erin and me, "Oh, you've got the same name—are you related?" we said, "No, we're not related." And then we thought...

EB

Why not? Let's just make this myth together.

The Journey Gestures[11] *are five synchronized, choreographed actions, as described below, corresponding with each of the following spoken lines.*

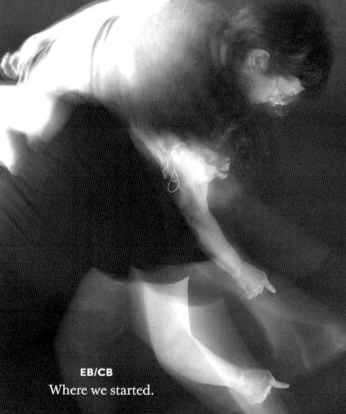

EB/CB
Where we started.

Crouching low to "draw" an x on the ground with the index finger, marking the point of departure.

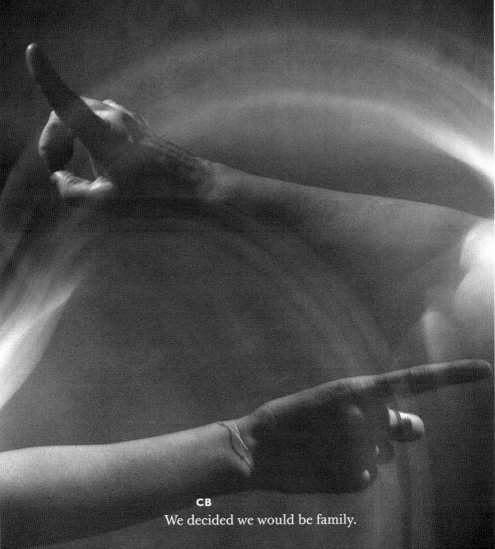

CB

We decided we would be family.

The right and left index fingers are raised vertically, side by side; one finger stays in place while the other describes a full circle in the horizontal plane, returning to the side of the other at the end.

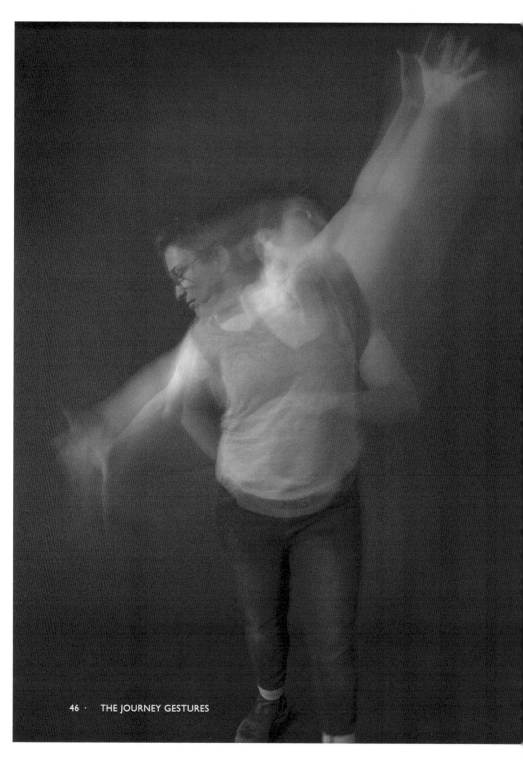

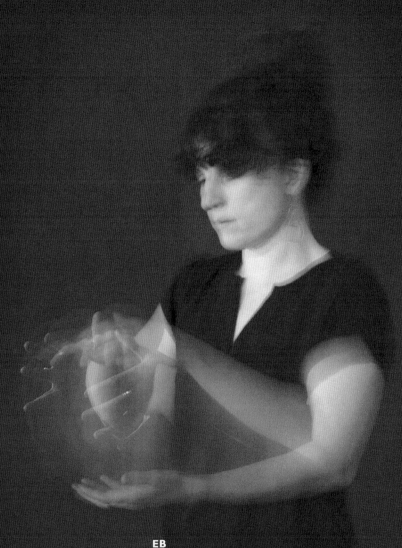

EB

The distance between things.

*Two seemingly opposite forces come together and interconnect,
forming a rotating circle in front of the solar plexus.*

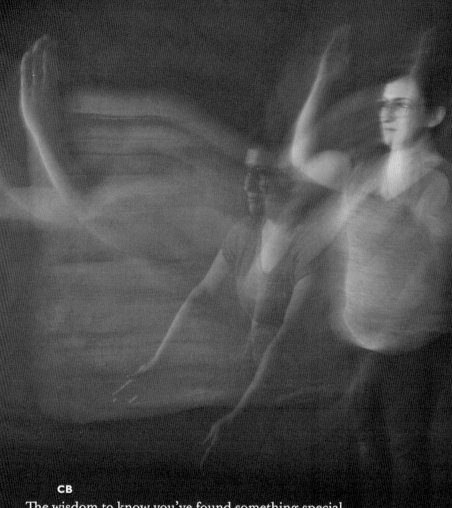

CB

The wisdom to know you've found something special.

Two forearms are raised vertically, with fingers pointed upward, to describe the sides of a frame or focal point for the performers' gaze. This creates a portal, an "opening" of space into which the performers "dive" and emerge in a new place, with a new perspective on their surroundings.

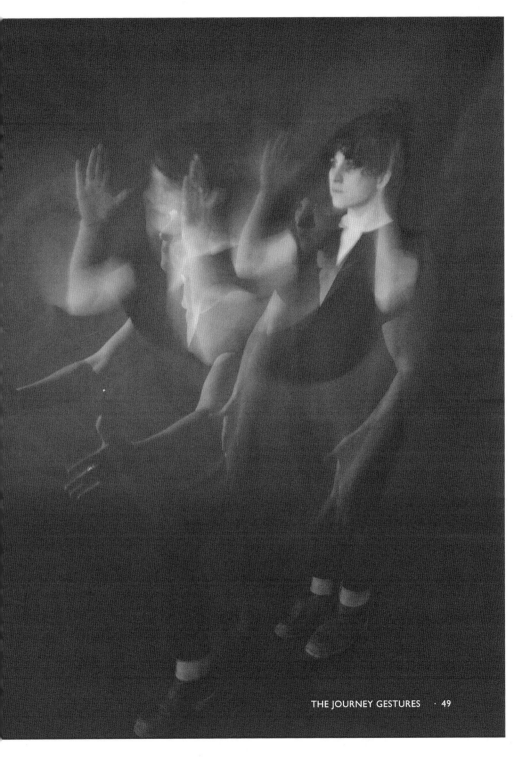

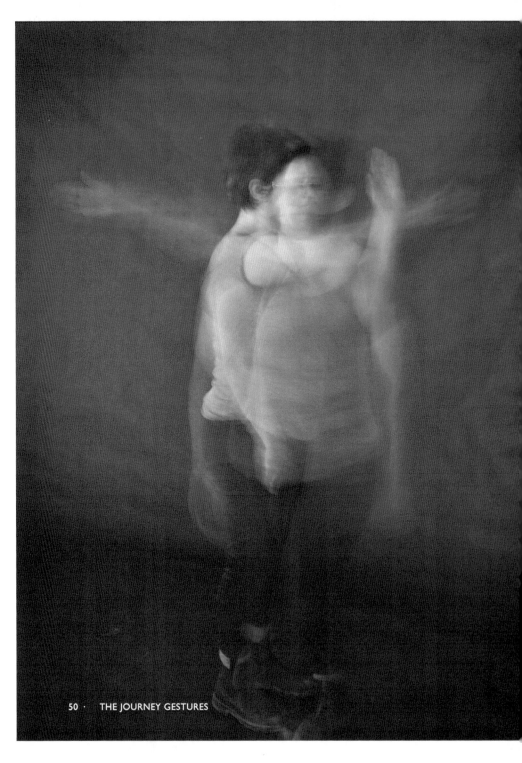

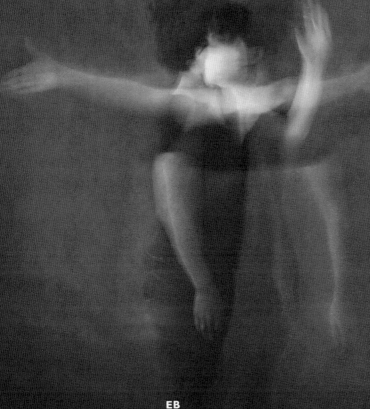

EB

The twist in the road.

From the last gesture, one forearm stays in place while the other hand swerves around the outer space, pulling the performer off their vertical axis, carrying them around an unseen corner.

CB

The Story About Erin.

EB

Okay. Well. When I was in high school in Toronto, I thought I might want to be an actor. I went to lots of plays, and one time I somehow saw the inside of a professional dressing room. And in that dressing room, I saw the name "Christine Brubaker" written on the wall. I wondered about her. After high school I moved away and became an artist of many kinds—*actor* was not one of them—and twelve years later I came home, and people started asking me if I was related to this Christine Brubaker. Turns out people were asking her the same about me. So, when we finally met at a party,[12] we decided we would tell people we were related. We'd had a few glasses of wine and we decided we'd make up some bullshit about being seventh cousins. We decided that we'd be family. She told her kids I was their cousin too. And then we read together about her ancestor going back to Switzerland for my ancestor, and the two of them travelling together to Pennsylvania on a ship, and one of their descendants who had walked from Pennsylvania to Ontario. And we decided to do it. There and then, on the spot. And I thought it was amazing to find a person who would commit to an idea and another person just like that. Just based on a feeling that took the form of a shared name.

EB

The Story About Christine.

CB

Okay. Well. I had been hearing about this woman named "Brubacher," and a few people had asked me if we were related, and I said, "No—it's not that remarkable a name." There's a gajillion Brubakers in the Kitchener–Waterloo, Ontario, area. Anyway, we're both at this reading and she comes over and introduces herself, and she's super-enthusiastic...and we both laugh...and we're both short...and we figure, sure, wouldn't it be a hilarious joke if we start telling everyone we actually *are* related. So, soon after, we decide we should make something together and we read a whole bunch of stuff about these Mennonites who walk from Pennsylvania to Ontario, and I'm pretty sure it's me who says, "We should walk it!" And she immediately says, "Yeah!!!" And though I'm totally enamoured of the idea, and of her, I'm also majorly skeptical that we can pull it off. Later, as part of our research, we go to a church service in Kitchener–Waterloo, my sister's church, a Mennonite church. We're on our way there, and even though we're late, Erin insists we stop for a coffee. A recurrent theme, I will soon find out. When we get to the church, we sneak in, sit in a back pew...and the sermon is about walking! Erin can't believe it. For her, it's like a movie where the minister tailors his sermon to bring the lost sheep back into the fold. But for me, it is like a bad hangover...old ideas, old feelings. This isn't straightforward fun for me. It's complicated. But, regardless, I remain committed and I follow her lead of talking it into being.

EB

The Story About Serendipity.[13]

EB retrieves two pairs of headphones attached to cellphones and unceremoniously passes one set to CB. The two glance at one another and put the headphones on at the same time. They each open an audio file for one of the voice recordings they made on the road.

EB/CB

One...two...three.

The two press the play button simultaneously and begin speaking what they hear, as they hear it. They perform themselves without affect. Their gaze is internal. They are in their own world of two. The tracks play loudly in their ears and they speak the following at a heightened volume:

CB

I was more like, this morning, kind of going, fucking hell, I should have fucking looked at those maps! What the hell! I gotta look at those maps! I gotta pay attention! Erin maps it out, she's good, but she doesn't always pay attention. Right? To the direction—

EB

I don't.

CB

No, you don't. It's okay. It's a good thing to know. I've just gotta—I just have to, like—

EB

Well, also—

CB

I can't just let you be the route person. You can be the trail master, that you set the trail—

EB

I'm the trail master, you're the...you're the navigator.

CB

Yeah, I think that has to be the way.

EB

'Cause I, I just kind of—

CB

You lose yourself.

EB

I don't care, is the problem. And I should.

CB

Oh my god! Think about three hours of walking! Don't you care at all?

EB

I just kind of— Because I have a deep desire to wander. And I know it's the wrong desire, because getting lost is not really a good option. But I'm kinda curious what happens, so there's something inside of me that doesn't deeply care about going the right way. So, I don't really...take it into myself. But also, this morning, I tried to do it on purpose, in a way—

CB

I know!

EB

—because I said, "Let's not follow a map!"

CB

And I was thinking, that's a bad idea! But I just thought, you know what? We'll follow it, we'll just go—I was literally going—going— and you know what I was also doing? I was going: How many times have we gotten lost? How many times have we kinda gone, like, way off course? And I was, part of myself was going: every time that Erin—every time I've left the map to— That's not true, actually that's not true at all—but I was deciding that it was every time I had let you just, like, take over the maps—

They laugh.

EB

It's not true though!

CB

It isn't true. I totally know it's not true.

EB

I have always had no sense of direction.

CB

Right. Right.

EB

None! But, like, it's uncanny. But, and, and, I guess, like, I kind of, like, I see it as a completely...a total flaw...and also a gift—

CB

Sure.

EB

You know? Because what it does is it creates all these serendipitous things in my life.

CB

Huh.

EB

This kind of, like, you know, I meet people because I kinda get lost. You know? And I have to ask, and— You know, and then other things happen that wouldn't have happened...

CB

You know what you have, Erin? I wouldn't say that that's your gift. You have the gift of *optimism*.

EB laughs.

CB

And it *is* a gift, right? It's an excellent gift.

EB

But it's also a little bit like, um...like, this is, this is what I'm so interested in about serendipity? As a concept? So, do you know where serendipity comes from?

CB

I feel like I do know, because I feel like I talked about this in my MFA. And it is something— Or maybe you told me about it.

EB

I might have.

CB

Maybe you did. Okay, tell me.

EB

So, it's something, it's like one of those things— Do you have anything in your life that you start to research, and you never finish researching, and you kind of keep coming back to it once in a while?

CB

Yeah, yeah.

EB

So, serendipity's one of those things for me—

CB

Maybe you've—yeah, you probably talked about it before.

EB

And, uh...I feel like I haven't, like, reached the end of my serendipity research, you know—

CB

Mm-hm. Mm-hm. Mm-hm.

EB

—but, I do know that the word originates with a story, about the three princes of Serendip.

CB

Oh! No, I don't know this. Cool.

EB

And...um...like, the word didn't exist before.

CB

Right.

EB

So, in fact, it was like coined based on this story—and the princes were called the Princes of Serendip. It doesn't have an etymological root beyond that.

CB

Yes. Okay.

EB

And, um...basically...their father sent them on a journey, or a quest of some kind, and um...uh...they...

CB

Where was Serendip?

EB

I don't know. I don't know if it was a place, even. It might have been a family. Or a kingdom, or— I don't know, I guess I don't know.[14]

CB

Or is it *a story*?

EB

It might be a story. It might be a story. I think it—it probably is a story, actually.

CB

Well, before you decide, let's find out.

EB

Yeah.

CB

I like how you—"I think it is probably a story"—I like how you, like, you make a decision: "It's a story."

EB

"It's a story." Well, we can find out still!

CB

Yeah, totally! Yeah.

EB

Me saying it's a story doesn't mean we can't find out.

CB

That's true. Yeah.

EB

So—and I can't remember the details of where they were going or what they were seeking, but the point is that their father had sent them on this journey because he believed it was an important element of their education. And, um, basically there were all these things that they were able to...to...um...I want to use the word *'divine,* but, like, to determine, you know, to find the answer to— through what we now know as serendipity. And, so, how they were able to find these things out is, like, on the trail, they saw, like, clues. Of certain things. And then they would meet somebody, and they would say, "We're looking for this goat." And then they would be able to determine, "Well, like, actually, because we stumbled into that person over there, and we saw a track here, and this happened there, your goat's over there!" You know? This kind of—

CB

Right.

EB

—stuff. And then that helped them along, because then they were able to get to their next stop, because whatever they were able to find out created goodwill and such. So serendipity is not just chance or luck, but it's like, when you find something you were seeking, that you didn't know you were seeking—

CB

Mm-hm.

EB

—and you're able to recognize it when you see it, because of some wisdom you've built up.

CB

Cool.

EB

So, there's—

CB

Knowledge.

EB

Yeah.

CB

Knowledge.

EB

But, but—but not just knowledge, like a sense of, like...It's the wisdom to know you've found something special when you—when it is presented in front of you—

CB

Right.

EB

—instead of just, like, seeing it and not taking it in.

CB

Right. Right.

EB

Or something like that.

CB

Okay. Right.

EB

Which I feel is a bit of a magical thing. Which might have something to do with optimism. I don't know.

CB

I think so—I think you make things, you, you imbue, you imbue experiences regularly with a, a specialness—a, a meaning...uh... You are creating meaning all the time. Yeah, it's just—

EB

Look at this beautiful drawing!

CB

Yeah.

EB

But, um...But—

CB

Look at that, we're in Milton.

EB

Great! *(Pause.)* That's a beaut.

The track concludes, and they take off their headphones, together. Shift.

CB

Name tags?

EB

Postcards.

EB and CB approach an audience member seated near the apex of the circle and hand the person a name tag that says HANS. In doing so, they ask that person to represent the patriarch of their shared Brubacher/Brubaker lineage. Working outward from HANS, they break off in separate directions, offering name tags to additional audience members who will represent each generation of relatives along the two branches of their Brubacher/Brubaker ancestry.

CB

At different points in history, there were many reasons why Mennonites migrated.

EB

Persecution, prosperity, adventure, hope, belief. But before they fled Europe, they suffered and were vulnerable.

CB

Some sailed across the Atlantic Ocean to safer land in Pennsylvania.

EB

Later, some of them walked to Ontario.

CB

In Pennsylvania and Ontario, they bought and were given land.

EB

This land was stolen. Much of it remains unceded.

CB

Some of the peoples who were there before Mennonite settlers are now gone forever:

EB

The Susquehannock of what we now call Lancaster, Pennsylvania.

CB

Many of them are here, resisting, still fighting for their land, languages, and cultures today:

EB

The Haudenosaunee Six Nations of the Grand River in Ontario. The Haldimand Treaty, established in 1784, was originally 950,000 acres of land promised to the Six Nations people covering six miles on either side of the length of the Grand River. Waterloo Region, where we ended our walk, is located on the Haldimand Tract, which has now been reduced to approximately 48,000 acres.

CB

Some of our ancestors were friends and allies of these nations.

EB

Some were unwitting—or witting—profiteers.

CB

What's clear is that our ancestors were some of the first members of the settler culture in this place we now call the country of Canada. We are on a journey of learning how we got here and who was here before us.

Shift.

EB

If you have a name tag, could you please stand up? Thank you.

Erin places a stanchion displaying the Brubaker/Brubacher/Bruppacher coat of arms in the centre of the audience circle, marking a finish line.

EB

In 1749, in the Netherlands—

CB

—our ancestors—

EB

—two cousins—

CB

—John Brubaker—

EB

—and Abraham Brubaker—

CB

—who were exactly twelve years apart in age—

EB

—boarded a ship: the *St. Andrew.*

CB

They sailed across the Atlantic Ocean and landed in Pennsylvania.

EB

It's a true story.

CB

This is how four hundred years works.

EB and CB each reach into a pocket and produce their own set of Mennonite-country road-trip postcards upon which they have handwritten their following texts. They position themselves in front of the person who is wearing the HANS name tag. As they speak the following lines, each reading from her own postcards, they move to stand in front of each successive audience-member "relative" (i.e., those wearing name tags for the names bolded below). After a postcard is read, it is immediately thrown onto the floor in the centre of the audience circle. The following two sets of lines (EB/ CB) are spoken at the same time, as fast as possible. It is a game. A competition. Whoever hits the "finish line" first wins.

Switzerland, 1661. Hans, a.k.a **John Bruppacher**, had two sons: **Abraham** and **John**. Abraham lived in Brubacher Valley in Switzerland and had a son named **Abraham Brubacher**. Abraham, when he was eighteen years old, sailed with his cousin **John**, and John's new wife, to Pennsylvania on the ship the St. Andrew, in 1749. Abraham was twelve years younger than John. Abraham had a son named **John W. Brubacher**. I don't know too much about this guy. But he had a son named **John H. Brubacher**. Again, I really don't know too much about this guy. But, you guessed it, he had a son named John, **John W.** John W., when he was twenty-two years old and sick of Pennsylvania, traversed the Allegheny Mountains and the Niagara River into Canada, across the infamous swamp onto new terrain, entirely on foot. He walked the entire distance from Pennsylvania. John W. had a son named **Henry M. Brubacher**. Again, don't know much about him, but what is interesting is that he had a daughter: **Annie Brubacher**. Up till this point we have adhered firmly to a patriarchal line, because that's how names have been given and records have been kept, but in my story Annie comes next. Annie Brubacher was the mother of my grandfather. You may be thinking, isn't it curious that he took his mother's name? But, in fact, Annie Brubacher married a Brubacher, so our line was not broken. Anyway, Annie had a son named **Emmanuel Brubacher**—my grandfather—who left the old-order community with the rebellious act of buying a car. Emmanuel had a son named **Mark**, who is my dad. And then there's **me**!

Switzerland, 1661. Hans, a.k.a. **John Bruppacher**, had two sons: **John** and **Abraham**. John emigrated to Pennsylvania and had a son named **John Brubacher**. John, when he was thirty years old, went back to Europe to find a wife. He then sailed back to Pennsylvania on the ship the *St. Andrew*, in 1749, with his new wife and his cousin **Abraham Brubacher**. John was twelve years older than Abraham. That's an important detail. John had a son named **Jacob Brubacher**, who married Susannah Erb. Jacob had a son named **John E. Brubacher**. In 1815, John E., when he was twenty-two years old, traversed the Allegheny Mountains and the Niagara River into Canada, past the last town of Dundas and across an infamous swamp. He convinced his widowed mother and wife, Catherine, to join him in 1816. His mom, Susannah Erb, was a savvy businesswoman. She ended up owning twenty per cent of all the land in the area and killed a rattlesnake with her bare hands. John E. had a son named, you guessed it, **John E. Brubacher**, who built a house in 1850, which still stands on the corner of the University of Waterloo property. John E. Brubacher, of the John E. Brubacher House, had a son named **John M. Brubacher**. John M. had a son named **Edwin Brubacher**— my grandfather—who left the Mennonite Church in 1918 when he joined the army in WWI. Mennonites are pacifists. This wasn't a good move. Edwin had a son named **John Edward**, who was my dad. And then there's **me!**

The winner grabs the coat of arms and is acknowledged by the loser. The two catch their breath.[15]

CB

Nine Johns between us.

EB

Almost four hundred years.

CB

Seven kilometres from my house to your apartment.

EB

Seven hundred kilometres from Pennsylvania to Ontario.

CB

And just like John—

EB

—and Abraham, cousins who took the ship together in 1749—

CB

—we're exactly twelve years apart.

EB

Eighth cousins once removed.

CB

On our grandfather's side.

EB

On our grandmother's, we're sixth cousins. But that's another story.
Thank you. You can sit down.

Shift.

CB

Who has a photo they want us to remember?

CB collects three photos from the audience and goes to the document camera. EB waits at the other side of the room.

For this round of the Photo Game, the person keeping time also controls the photo display, herself controlling how much time the other has to speak about each image. The time limit is reduced to one minute.

(The following photo games are transcribed from performances on Sunday, June 3, 2018, at the Ismaili Centre of Toronto, and on Sunday, September 24, 2018, at St. Matthew's United Church in Toronto.)

CB

Erin has *one* minute to remember these three photos. One minute, three photos...Go!

EB

Oh! Okay! So, this is a sign that we saw at the Pennsylvania Grand Canyon, and what I really enjoyed about this sign is that it's a picture telling you which kinds of snakes are venomous and which are not. And all you need to know is that the one that looks mean will hurt you. And the one that has the happy, friendly eyes is okay.

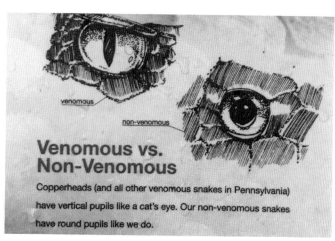

venomous

non-venomous

Venomous vs. Non-Venomous

Copperheads (and all other venomous snakes in Pennsylvania) have vertical pupils like a cat's eye. Our non-venomous snakes have round pupils like we do.

Um, okay, so this is a motel that we stayed—it was pretty early in the journey—and, um, I remember we didn't sleep a wink the entire night because Christine said to me as we walked in, "Did you check on the internet if there are any reviews about bedbugs?" And then I spent the *whole night* stressing about the bedbugs and I went to the desk and I actually said—I pretended to be, like, really young—and I was, like, "My mum made me check if there's bedbugs, could you tell me..." Okay, so, um—

CB
Ten seconds!

EB
Oh! Okay! This is a family that we stayed with very near the end of the walk, I think it was in Canada, and I think we were just so tired that I don't remember anything about this meal. And that's, maybe, all I have to say about—

Timer goes off.

EB

Who has a photo they want us to remember?

She collects three photos from the audience.

EB

Christine now has *one* minute to remember these three photos. One minute, three photos...Go!

CB

Okay, this looks like...oh...um...uhhh...I...Oh! Okay, this was a really cool family we stayed with, another home-schooled family, we stayed with a lot of very, um, uh...sort of right-wing Christian families who were, um, operating maybe in a different political landscape than we were...and that we, uh...These guys had this incredible group of kids and were

home-schooling them and they were there and they made us this big bonfire dinner and, um, they insisted that we clean up and they said, "Any guest is a part of our family and if you're a part of our family then you have to clean the table just like everybody else."

CB

Uh, okay, this is a bridge that Erin talked a lot about and was super-excited about wanting to see, and when we got there, she sort of said, "Well, I'm going to take a lot of time, I'm going to take a lot of photos around here—"

CB

Oh, well, there you go, wow. Right, um, eat! Right. The Divine Swine. This was a place just outside of Lancaster—

Timer goes off.

CB

Excellent.

EB

I'm sorry. I didn't give you a warning that time.

CB

No, it was good.

Shift.

CB

So. I recognize in myself a family trait I inherited from my dad—you don't make things bigger than they are. Things are what they are. And there is no valuing of one thing over another: one child is not more than another, one birthday is not more than another, one day is not more than another. And in some ways, there's an equality that exists that's incredibly beautiful. There's no pressure to be or to make something into more than what it just *is*. But then, in other ways, there's a lack of specialness. Erin says her dad is looking for the special all the time. She does it too.

EB

On the walk, at the end of the day, we wrote things down.

EB holds up two stacks of kilometre markers[16] and hands one to CB.

CB

Took notes. For ourselves to remember.

EB and CB position themselves at the 0 kilometre marker on the kilometre route. They read the following journal entries from the backs of each kilometre marker; each marker card indicates the kilometre number on the side visible to the audience (for example: "17km"). They move incrementally along an undescribed path, alternating between walking, pausing, reading, and then moving past one another en route. After reading the journal entry on each marker, they place it on a wall or in a stanchion, gradually leaving a trail of ascending kilometre markings, mapping a crude, sloping trail around the room. Somewhere along the way, their journey emerges.

CB

0 km. She brought too much stuff. I'm intimidated by her articulateness, to the point where it irritates me. I don't have the words. She has many.

EB

0 km. I haven't actually considered, before now, that spending this much time together might be difficult. It's obvious. But I hadn't thought about it.

CB

17 km. She is always shooting/collecting. Me, I don't know what I am collecting. It's okay to sit back, I tell myself, I collect in my head.

EB

17 km. I have so many images in mind—many old playgrounds punctuating the land; the details of each home—a pin cushion...I realized I'd be totally upset if I didn't make photos along this journey, just to avoid conflict with Christine.

CB

38 km. We both apologized, and Erin made me eggs. She's a great cook, but her sense of time is very different than mine.

EB

38 km. The land we are walking through is so beautiful.

The two stop reading from the kilometre markers and address the audience.

CB

On the road, while we were walking, we also made recordings.

EB

With our cellphones.

CB

One of us would press record, and sometimes we'd even forget to turn it off.

EB

When we got home, there were over seventy hours of these recordings.

CB

This is one of them.

EB

We're speaking our own words, as we hear them, in real time.

CB

The Story About the Train Tracks.

The two turn and put their headphones on at the same time. They take their phones from their pockets and each opens an audio file for one of the voice recordings they made on the road.

EB/CB

One...two...three.

The two press the play button simultaneously and begin speaking what they hear as they hear it. They play themselves. This time, through speakers in the room, the audience hears a recreation of the aural world of the walk as it is in the recording that EB/CB are listening to: trucks passing, feet on gravel, birds, etc.

EB

Okay, let's just pay attention here for a minute—

CB

Yeah, we should. This might be dangerous—

EB

Should we kinda run?

CB

I don't know, like . . . does this look like a high-speed moment?

EB

This is a really interesting intersection.

CB

Yeah, this is a bizarre roadway.

EB

Oh, yeah! Highway 147.

CB

Yeah, it might not be beautiful.

EB

I kinda like it though.

CB

I do too—

EB

The rails?

CB

This, this is what we need to watch. This guy...make sure he's not turning right.

EB

Maybe we can walk along the rail track.

CB

Maybe...If...Maybe, maybe we can. It feels maybe slightly unsafe. It depends what the shoulder is.

EB

Yeah. Should we go look?

CB

Yeah.

EB

It might be more shady over there too.

The two get farther apart, investigating parts and sides of the rail tracks to walk on.

CB

What's the sidebar, what's the shoulder?

The sounds of their footsteps.

CB

What about walking on the track, in the middle?

EB

That makes me really nervous.

CB

Okay, okay. Yeah, I don't know...

EB

Oh, it's so cool here!

CB

Is it a good walking area?

EB

Probably not.

CB

Pardon me?

EB

I said probably not.

CB

This—this looks like unused trail.

EB

Oh, that's true, the middle's unused!

The two get closer together again. You can hear the sound of them walking on the gravel between the tracks . . .

CB

Yeah. So, we just gotta really, really pay attention though. This could be bad news, right? People are going to come speeding through at high speeds. I . . . don't know, I just don't think it's wise to be walking around on the—

EB

Would we hear it?

CB

Well, I don't know. I just don't think it's wise, Erin.

Silence.

CB

It is nice and cool though—

EB

Wish I knew which way the train comes from.

CB

What's happening over there?

EB

Well, they come both ways.

CB

Yeah.

Silence.

CB

Let's try it for a little while

Their pace picks up. Sounds of walking on gravel.

EB

I mean, the train does not go here, in the middle. It would just be scary—

CB

I would hope not—

EB

Well, it can't—

CB

I don't know though. Are we going to become a train story? Two hikers killed on a train track?

EB

No, but it can't go there.

CB

Right. Right, of course—

EB

A train's not wide beyond that rubble.

CB
You're sure about that?

EB
(Laughs.) Well, now—

CB
It seems like a good instinct. I just have no idea if that's true or not. I have nothing to know about that.

EB
Like, y-uh... Yeah, I don't think a train can come beyond that rubble. So, it's not going to hit us, but it will scare the shit out of us.

CB
Yeah.

EB laughs.

CB
I actually don't like it. As a parent, I don't like it.

EB
No, yeah. It's not great.

CB gets farther away, she is moving off the track.

CB
But.

EB

But it feels really good.

CB

It's— Go for it. If you feel like it. If you wanna walk there for a while. I think you're totally safe. I just think, it's not gonna be me.

EB

Where are you gonna walk? On the road?

Sounds of birds. No audible answer from CB. Sounds of EB continuing along the tracks.

EB

Now I'm scared.

The track concludes. They acknowledge each other and take off their headphones together. Shift.
 CB steps out of the audience circle and puts on her headphones again, using the built-in mic to make the following "phone call." Her call is interspersed with EB's text. EB idles, listens, and addresses the audience, pausing to allow CB's text to interject.

CB

On the road, I called my kids every morning and night: Hi, darlin', how are you? We're just driving around, getting a tour of all this beautiful farm country from our host.

EB

While Christine talked to her family, our host, the eighty-two-year-old farmer we stayed with, tried to set me up with his grandson.

CB

I just wanted to call and make sure—are you guys going to bed already? Okay. So maybe I'll call back in fifteen or twenty minutes and say goodnight. Is that good?

EB

Christine talked about her husband and children. She showed pictures, deflected any suspicion of heathenness with her family.

CB

Hey, sweetheart...did you guys go to the Pan Am games tonight? Oh, was it gymnastics? Women's or men's?

EB

Most of our hosts read me as a young, unmarried twenty-five-year-old, and I often let them.

CB

So, you had a good day?

EB

They were so kind and generous with us, and most of them made me feel very welcome—

CB

Oh, so nice. Okay, so I'll call back in fifteen or twenty minutes. Just to say goodnight.

EB

—but, somehow, I felt I'd be less welcome if they knew I was a divorced, childless, thirty-five-year-old.

CB removes the headphones and addresses the audience again, moving back into the present action with EB.

CB

We could tell you more about the eighty-two-year-old farmer. We could tell you about the prison chaplain, or the gun collector, or the woman who made us a foot bath.

EB

We could talk about the baseball enthusiast, or the people who lived in a house of darkness, the couple with the player piano who fought a pipeline project, the family who baked the neon birthday cake, the bartender and her girlfriend, or the woman who loved short stories. But we know we can't tell all the stories. You can never tell all the stories.

Shift.

CB

The Story About the Baptist Pastor's Wife.

As EB recounts the following, CB sits at the document camera and hand-draws a small visual "map," illustrating parts of the story with stick figures, lines, and symbols.

EB

Okay. Well. She was special in a few ways. We had just gotten to this tiny town, at the edge of Pennsylvania, nearing New York State. We arrived earlier than expected and were really excited about having some rest alone before going to the home of our next hosts. We were looking for the one diner/café sort of place in town.

All these towns have, like, three churches, a post office, and one other thing—usually a bar or a diner...or a legion. So we're looking for the diner and we hear this person call out to us: "Hey, what are you girls doing?!" And there she is, holding this huge stack of library books—she had seen us with our backpacks and it was clear we weren't from around there—and she's like, "Hey, why don't you join us for lunch! I always make extra..." And we're like: *Noooooooooo! We just wanted five minutes alone!* But we have to, of course—you can't say no to that. She introduces herself and tell us she's the Baptist Pastor's Wife. She's around my age and has birthed six children, plus they've adopted two teenage sisters from Ethiopia. So we get to this lunch of a family of ten, and we eat the beef macaroni or whatever it was, and her husband makes us amazing cappuccinos (he's gorgeous, by the way—they are all gorgeous), and they take us to their church next door, and CB plays the organ. A lot happens, including one of the teenage daughters being the first person to actually ask me directly about my faith. She was the first person I had an honest exchange with on the matter. Eventually we leave, and the next day we're walking and this minivan pulls up, and there they are with a bunch of their kids, and he's driving, and she jumps out of the passenger seat and says, "Hey! I wanna walk with you girls!"

So she walks with us. For about two hours.

And while we were walking, we talked about things, for real. What we really thought and believed. We asked each other questions. I remember at one point we were talking about gender roles and she said, "Well, I guess you too—you might also think, from an evolutionary perspective..." And I was so relieved. Because I knew *she* knew for sure that we didn't believe what she

believed. And it felt like it got more and more honest. And afterwards, Christine and I realized that the reason we could be so honest was because we were hosting her—she was on our turf on the walk. She was *our guest*.

CB

I invited her and her whole family to come stay at my house in Toronto—all ten of them.

EB

She did. I thought it was bonkers, but I also really admired that she did that.

CB

She said they wanted to come and seemed really excited about it.

EB

They even talked about dates. And the older girls got excited about the Ethiopian restaurants in CB's neighbourhood. But then we wrote her when we got home, and she never answered the emails.

CB

And we knew she was getting them.

EB

I wondered if they just got busy or if it was a choice. Christine thought she knew why they didn't come. But I kept wondering if we should call her and find out. It kept bothering me...But I never did more than think about it.

CB

A year after the walk, we were invited to perform in Pennsylvania.

EB

We drove back where we walked, and on the way, we stopped the car in her town and looked at her house. We saw her daughter, two years older, walk across the street and go inside.

CB

We knocked on the door and her husband, the Baptist Pastor, invited us in. All of their kids were there, sitting at the table having lunch.

EB

But she wasn't home. We told him about the story we tell you, about walking with her. I asked him to tell her that it meant a lot to me.

CB

We've had a few emails back and forth with him since. Where he thanked us for stopping in and apologized for not offering us something to drink. Then we exchanged more emails about racism in their town, after what happened in Charlottesville, Virginia.[17]

EB

But the correspondence was always with him. Her name is on the email address too, but she never writes or responds.

CB

I'm wondering if she prayed about it and decided it was better not to be in touch.

Shift.

EB

356 km. Last night's hosts made me very uncomfortable. They were very kind, and so happy to meet us, but I had this strong feeling I had no permission to be who I am in their company.

CB

356 km. I find it presumptuous that people will pray for us and touch us. Not sure why I'm feeling so strongly. Tired of being guests. Tired of walking. Just tired of being *on*. Why is God so present for these people and not for me? Why didn't it take?

EB

483 km. This morning I woke realizing that, whether I was comfortable or not, all those folks think we're going to hell.

Shift.

CB

The Story About the Teachings of Jesus.

CB and EB put on their headphones, take their phones from their pockets, and each opens another one of the voice recordings they made on the road.

EB/CB

One...two...three.

The two press the play button simultaneously and begin speaking what they hear as they hear it. They play themselves. The audience hears a recreation of the background sounds that CB and EB are hearing through their headphones: feet on gravel or dirt on pavement; cars and trucks passing; birds; wind; etc.

EB

So basically, I think it was hate spreading—

CB

Totally.

EB

—and I think that Jesus—like, I always felt okay in saying that I believed in the teachings of Jesus. You know? Well, I don't know them thoroughly enough—

CB

What are they for you? That's an interesting question.

EB

Well, you know, what I understood about them, from—this is all
secondary source, you know, because I never spent a lot of time
with the Bible—

CB

Right.

EB

—but my dad told me about...what they were.

CB

Uh-huh. Yeah.

EB

And then I met people along the way, like particularly this one
woman who I met in New Brunswick when I did my teaching
degree—no, sorry, I met her in Newfoundland, but she was from
New Brunswick—

CB

Uh-huh.

EB

—and she was a hairdresser who decided she wanted to get her
teaching degree, because she felt like she was a hairdresser to make an
impact on people's lives and she wasn't making enough impact being
a hairdresser, so she wanted to be a teacher—isn't that amazing?

CB

It is amazing.

EB

And it's true! Cutting hair; it's very personal.

CB

Absolutely.

EB

Anyway, she was like a real hippie Jesus lover—

CB

Wow.

EB

—you know, like the real deal, hearts on everything. Love, love, love. Right?

CB

I wouldn't say hearts are Jesus, but that's interesting.

EB

But, but, she would… I'm just saying that she also did that—

CB

Yes, right…

EB

—I'm not saying hearts are Jesus, just she loved Jesus, she loved hearts—

CB

Yeah...

EB

—she loved love.

CB

She loved love.

EB

All about love, right? And so I got sort of...I dunno, her version of Jesus, you know, was something I could understand.

CB

Oh. Cool.

EB

You know, but basically just like, you know, like, um...uhhhhh... caring for those who are less fortunate than you, and you know, not judgment, no judgment—like, it's not for you to judge on this earth—

CB

Right...

EB

—you know...and uh...like, respect for other people, and kindness and umm...you know, standing up for what you believe in—

CB

Right.

EB

—and you know, like all that stuff. So, I mean, like, you can interpret anything the way that you want to, right? But let's also put it this way: if there is a God, for me...

CB

Uh-huh...

EB

...if there is a God, that entity, this God, does not want the hate of *that book*[18] spread around, like where gay-bashing occurs, and like where a child is made to feel horrible because they don't feel like they identify with their gender or, you know, all these things, you know, that cannot exist for me.

CB

Right.

EB

So—

CB

The interesting—

EB

I feel fine, just fine about that.

CB

Yeah, I know, but the interesting thing for me is that, like, if we talk about the teachings of Jesus, I think that's absolutely right—that's absolutely one part of the story. Right? But then it gets into

slippery-slope stuff. Like, that's all kinda…like, that's why I have this reaction to it. People kinda say, "Yeah, I'm Christian 'cause I'm from North America," or whatever. Or, "I'm Christian because I'm not Hindu," or whatever.

EB

Yeah.

CB

And it's like…I almost find…it's like when people get married in churches who aren't Christians, I find it kind of offensive because I feel like—

EB

Oh, I agree.

CB

—it's a borrowing of selective pieces of that picture.

EB

Oh, I totally agree.

CB

So, that's when I kind of, like, I think it is big stuff to say the teachings of Jesus— I think we kind of have to take it on. If we're gonna look at it, I think we have to take the whole thing, and that's what—

EB

But I only say it as a way to connect, 'cause I'm looking for something—

CB

Yeah, but that's what I mean. I don't mean it's facile, but there is an *easiness* to it, there's a simplicity to it, and I do think it is as simple as it is complex. And so...so when people, these people, think they're doing the teachings of Jesus...And it's just, to use it as a justification, I find, I...It just makes me anxious, I feel worried, you know, it's a term that's bandied around a lot, and I'm suspicious of it. Because it's used to wield a lot of different justifications—as opposed to saying: You know what? In my heart, this is wrong.

EB

Oh, you don't have to sell me on any of this.

CB

Well, I'm just saying my experience. I'm not selling you on it, I'm talking about my experience right now.

EB

Yeah, yeah, yeah, yeah, yeah.

CB

We're not, we're not in an argument right now—

EB

No, no, no, no, no, no, no.

EB and CB remove the headphones and each produces a kilometre marker from which they read the following:

EB

656 km. We're getting close. CB is anxious to get home. Or she's ready to be home. We talked about it today and I burst into tears. I don't know what I'm going home to.

CB

685 km. People are meeting us today to walk with us for the final hour. Part of me just wants to finish this thing without fanfare.

EB and CB continue to place the kilometre markers on walls or in stanchions, adding to the visible route now forming in the room.

EB

One Story About Christine. Okay. Well. I learned about this woman, Christine. She walked for seven hundred kilometres over thirty-two days. She had the idea and just decided to do it. Just committed to doing it on the spot. She was obviously looking for something—not in the usual way of trying to find out who she was, or to find peace after some traumatic event, but looking to satisfy some desire inside of her. To be able to say that she really left the "noise" of our contemporary world: the city, the social media, the hype about anything. She didn't want the walk to have to mean anything other than that she did it. She was really proud of herself for doing it. And she knows she'll remember it forever. But she also knows it wasn't all she wanted it to be, because it wasn't the right time for her. She did it because she said she'd do it and because she truly wanted to do it, because it was an incredible thing to do. But she'd been travelling a lot for work and was a mother of two young children, and while part of her deeply wanted to be on this journey, part of her was screaming: *Why aren't you home?* And not because of some bullshit about how mothers aren't supposed to go away, not at all, but because *she* needed to be home, at that time, for herself. And here she was doing this once-in-a-lifetime thing that was happening at the wrong time, for her. And she fully committed to doing it and it was incredible. And it really did mean something to her. But she wasn't going to mythologize the wonder of it, because in the end, it wasn't what she needed. So now she never says: "I wish I was back on the walk today" or "What a remarkable time in my life," because the truth was, she was just glad to get home.

CB

The Part About The Questions.

With each question, cb and eb approach and address a new audience member.

EB

What draws us to another person?

CB

What are the stories I repeat?

EB

To what extent do we measure ourselves against someone else's normal?

CB

Do adventures activate desires? And is that a pleasant feeling in everyone?

EB

Why did they swim the Niagara River at the farther end rather than the closer end?

CB

What kind of socks do you think they wore?

EB

Can they eat a meal without praying or is that against themselves?

CB

Do you like it when someone worries about your spiritual life?

EB

Can a person practise gratitude without dedicating it to a god?

CB

What are the birds doing right now?

EB

Do you know how much time a kilometre is?

CB

Do you have an innate sense of direction?

EB

Do you ever get lost?

CB

Am I really such a grouch?

EB

Am I too much?

CB

Did I hurt your feelings?

EB

Was I being thoughtless?

CB
What did you say?

EB
Should we take the bridge?

CB
Should I look at the map?

EB
Do you need an Advil?

CB
Should we cross the road?

EB
Can you look at this rash?

CB
Do you really want to carry that beer?

EB
Did you see that?

CB
What is a story? Why do I resist it? Why do I want it?

EB
What are the stories I repeat?

CB

What is the difference between your version of a story and my version?

EB

(To CB) Can you leave the room?

They look at each other. CB leaves the room.[19]
EB makes a confession to the audience.

EB'S CONFESSION.

THIS CONFESSION IS A SECRET.

WHAT IS WRITTEN ON THE NEXT PAGE
WILL NEVER BE READ BY CB.

This is the part I'm calling a confession. While we were on the walk, Christine and I would often recount things that had just happened to us. And what we would find was that her sense of things and my sense of things were different. And these were things that had literally just happened to us sometimes. Sometimes we would experience something together, and then twenty minutes later, our versions would be completely different. And we would argue about the facts, and I would always dig in my heels and adamantly defend my version of things. And I kinda still do this—when we talk about the walk, or when we are just in each other's lives...I always think my memory is accurate. But lately there have been some things that have made me question the accuracy of my memory. For example, a couple of weeks ago I was talking with Erum about a book that we both loved called The Accident of Being Lost, by Leanne Betasamosake Simpson. And I said, "Remember when I read you that passage on the phone?" And she said, "No." And I said, "What do you mean? You don't

remember me reading you that passage?" And she said, "Oh no, I remember you reading the passage, but I wasn't on the phone—I was in your kitchen, I was sitting next to you in the kitchen." I said, "No, no, no, you were on the phone, I remember. I was doing my dishes and you were on the phone and I was reading you the..." And then it started to get a little bit implausible. I'm suddenly realizing I don't have enough hands for this—to have the phone and the book and be doing the dishes... but in my mind, it was so clearly on the phone. And so little things like this that don't really even matter have made me start to question my memory. Because whenever I'm with Christine arguing about something, memory— accurately recalling an experience—is kind of a big thing... And I haven't actually admitted this to her. I might tell her sometime—but don't you tell her because I haven't told her yet... But for now I just wanna say that I really value that Christine trusts me enough to never ask and to never know, what I say to you in this moment of something that she has made.

CB

The Story About The Woman Who Offered Us a Ride.

EB

The first day:

Erum Khan (EK), the production assistant, plays an audio recording of CB/ EB on the road, speaking the following:[20]

EB

—and then she also talked about like...she and her kids being in musicals, amateur theatre and stuff.

CB

Yeah.

EB

And she's like, "I like art," and talking about all these things—

CB

—Yeah.

EB

So we're gonna go to the art gallery tomorrow and then we're gonna go into town. Probably have a good coffee!

CB

Coffee. Yeah.

EB

But we missed the most important part—

CB

Oh! She'll be dead from colon cancer or almost dead—

EB

Two years ago she was diagnosed with colon cancer—

CB

Yeah. And how she said was blessed to get cancer—

EB

Yes, and she said that actually what they said is that she was supposed to die, like, next month. And she's in such great shape. And she's so vibrant. And she kept saying—she said, "I am. I'm in great shape. I don't know why I'm still here." And she said that she thought she appreciated things before but she did not—

CB

She didn't. I know. Such confidence. This knowledge she gained, hey?

EB

Yeah.

CB

And then she talked about how she—what she . . . Like the smallest detail that was the part that kind of blew me away. How she—when she had to have a tube in her throat for I think she said six weeks or something like that. And that she couldn't drink a sip of water. She wasn't allowed to drink one sip of water and how agonizing that was. Then finally when she did get to have one sip of water, how incredible that was. And then she talked about this ambulance driver that was

driving her, and I didn't—I wasn't quite sure what part of the journey that was on, but it was either to or from the hospital, and how he pulled over and put her into the sunshine so she could feel the sunshine on her face. And at that point, that was when I was almost wanting to be a blubbery mess in the back of the car. It still makes me feel so moved that she's…I don't know…essentialized these moments for herself and has actually gotten to be that clear about what matters.

EB
And she also said, "I'm still looking for what my purpose is."

CB
Oh, she did say that?

EB
Yeah.

CB
And now she's gonna be starting to house homeless people? Is that it?

EB
She said, "I know there's a plan and there's a reason I'm here. I don't know what it is yet."

CB
Wow.

EB
Yeah. Do we want to cross this bridge?

The audio recording ends.

CB

As you can hear, we were pretty affected by the Woman Who Offered Us a Ride. And it bears pointing out that she fully fit our *ride criteria*. You see, we had a rule on the road, one we both agreed on, that we could never accept a ride for convenience—only for reasons of *magic*. And this woman, who so inspired us with her clarity and strength, was completely magical. We were moved, in awe. AND we laughed our asses off with her—she was so much fun to be around! That was the first day. The *next* day, we spent the morning together. She showed us her town, she took us to a local gallery—and a fabulous coffee shop—and we're having a lovely time. And then...something shifted. Seemingly out of nowhere. Neither of us saw it coming. It became a conversation about religion. About race.

EB

It seemed to us that she was negating the ongoing repercussions of slavery.

CB

It was a conversation that made us both very uncomfortable. And it was confusing to know how to navigate it. After we left the Woman Who Offered Us a Ride, we recorded forty-eight minutes of a much longer conversation while we walked. In that conversation, we tried to unpack what had just happened—how we both responded. Every time Erin and I get together to do this show again, we continue to unpack that day and the bigger questions of *how to be together*—with each other, and with other people.

CB selects a person from the audience and asks:

CB

Can you pick a number between one and forty-eight?

They do. (For example, "Seventeen.")

CB

Thank you. Erum, can you play the track closest to minute seventeen? And set the timer for five minutes. Thank you. If any of you have any trouble hearing us, please just raise your hand like this *(they demonstrate)*, and we'll make sure to let the other person know.

Every time the show is performed, this improvisation is significantly different. We decided not to include any one version here. Instead, we interrupt the performance script to offer an overview of this part of the performance from Erum:

EK

During this part of the show, I play two or three tracks randomly chosen by the audience, for EB and CB to use as a starting point to pose each other questions. Each track is a short snippet from a conversation they had the day after they met the Woman Who Offered Us a Ride. CB and EB listen to a track. Then they wait until one asks the other an improvised, spontaneous question. The two take turns asking and answering questions, unpacking their current feelings about what happened back then, until the five-minute timer I set goes off. At that point, the person talking finishes her thought and the task ends.

I have seen this moment in the show shift considerably over time. I remember feeling excited during the rehearsal process when this non-scripted framework first emerged, as I had previously experienced complicated feelings about the presence of this story in the show and thought this new approach could steer it toward something that would address my initial concerns.

The complicated feelings began early in the process, before the rehearsals for the piece had even begun, while the materials for the script were still being assembled. I remember some of the earliest

conversations we had about the Woman Who Offered Us a Ride section during a workshop in CB's kitchen in her home in Toronto, and then later in the Nightwood Theatre rehearsal studio at the beginning of the first rehearsal process. I remember feeling like something didn't quite sit right. Of course, the Woman Who Offered Us a Ride's words were complicated to unpack and her statements filled with problematic language and ideas, but my only thought was "Why is this a big deal?" From my point of view, as a racialized person who has endured racist and xenophobic interactions in many occasions of my life, this was just another incident that held very little significance. Yet, as all the other collaborators spoke passionately and heatedly on the topic of how to dissect what this woman had said, I felt a sense of confusion and discomfort about how to contribute to the conversation. I thought maybe I was being insensitive—and as the youngest person in the room, and the only one without a clearly defined role in the process, early on I thought maybe it was best I didn't speak up, as I was probably missing something that all these senior artists and collaborators were attuned to.

But then the improvisational approach to this segment drew me in, and it was clear we all felt that this could push the show in a direction that would challenge both the content and form. I remember once walking late into a rehearsal when the others were in the middle of testing this proposal and being completely moved by EB and CB's improvised conversation. Instead of being fixated on questions regarding one specific encounter with race or religion, it turned into a deep, personal, honest sharing. There was a major shift in the room, and I saw how this moment of the show could deepen the experience of the entire piece significantly. It was exciting.

But after we began touring the show, the "improvised" conversations slowly returned to acknowledging race and religion, where on several occasions CB and EB would repeat the same types

of questions (e.g., "If you could go back, would you have responded or reacted differently to what she said?"). It started to feel a bit like an apology tour of two white people speaking out against what another white person said, rather than delving into anything with stakes in relationship to the present moment and the fundamental questions of how to be together. But we all talked about that, and we decided to keep at it, knowing that each new time had the potential of bringing about something new and challenging.

Then we took the show to Kitchener–Waterloo, Ontario. It was the final leg of the tour and the final set of shows we had scheduled. It was June 2018, and Green Light Arts was presenting us on the weekend of the Ontario provincial elections. After our first show, CB, EB, AN, and I were sitting in a bar in downtown KW watching the election results pour in, with the Conservatives about to win the election. We sat in complete despair, surrounded by a cheering, celebratory crowd. We were in some real mixed company. Right-wing, Donald Trump–style, Conservative Party leader Doug Ford became the premier of Ontario before our next performance. These election results transformed the the Woman Who Offered Us a Ride moment of the show for our next performance. There was a sense of immediacy that felt hyper-present in the room. I remember sitting behind the tech table, in this improvised moment of the show, watching EB and CB talk candidly about how the shift in governance would affect the sex-ed curriculum and making connections between *The Handmaid's Tale*[21] and our current society. It felt exhilarating and terrifying. It was difficult to know how this was being processed by the full-house audience (most of whom, unlike our other audiences to date, came from Mennonite backgrounds, and who, like EB and CB, were part of the direct line of settlers that came from Pennsylvania to settle Ontario). Some nodded, others bristled. They were implicated in the complexity. One thing was

clear: this moment had finally become something we were all hoping for.

After this performance, all the collaborators stayed around for hours discussing what had just happened and acknowledging both the relief of finding the manifestation of what we originally set out to do and having kept our promise of allowing the work to continue to evolve. It was a shift away from pulling something from the past and reflecting on it in the present, to using that as a pivot point into the here and now. The alchemy of the elections and doing the show in Kitchener–Waterloo pushed our collective understanding of this section into something a lot more interesting: being in a space and time together and unpacking the bigger questions of how to be together.

* *

EB

And now, a story about someone who was simpler for us to understand. The Story About Paradise. This time we'll play each other. Christine will be me, and I will be her.

At this point in the performance, and by this time on their walk, there is no more luxury of personal space. EB takes her phone from her pocket and CB plugs her headphones into a jack in EB's headphones so they are both listening on the same device and joined by cords. EB opens a file of another voice recording made on the road and presses play. The two begin speaking what they hear as they hear it. This time they each speak the other's words aloud; they perform each other:

CB

Um … first, I just want to say, what a fortune to go the wrong way sometimes. Um … the other thing is that, just, I just had to go back

a minute ago—because I forgot my pole—and, um, when I went back on...um...when I was coming out of the house again, uh, there was this metal trailer. I don't know if you saw it, Christine?

EB

That's the—that's the—the thing I kept talking about—the uh...the uh...Airstream.

CB

The Airstream!

EB

That's why I kept saying, "Yeah, yeah! Airstream!" We were talking about how she was going to build a thing around it.

CB

Airstream! Okay! I didn't know what an Airstream meant exactly—

EB

Oh, I'm so sorry!

CB

I was going to get back to that and ask you about that later. *(CB laughs.)* Okay, well, I hadn't seen it before. So that's neat. It's like we had two rounds of this same encounter—but, anyway, but I just said, I just said to her, um, "Oh, wow! Look at that. What's that about?" And her answer was "Dreams." And I thought that was so wonderful! She said: "Dreams."

EB

My God, Robert, he would—I just wrote, actually, Robert, a big email about this place—

CB

Oh, very nice.

EB

—and I called her, like, a Renaissance woman.

CB

She is!

EB

Totally.

CB

She does everything!

EB

She does everything.

CB

And—

EB

She can.

CB

—she's so good at making dreams. Like dream follow-through. Wow, look at that sky ahead.

EB

Yeah.

CB

And—

EB

They talked about tornadoes today too.

CB

Ah, yeah, tornadoes.

EB

You know what else she said, which I thought was really cool, was, she goes, "I think you've found a kindred spirit!" And—

CB

She did!

EB

—all I thought about was *Anne of Green Gables*.

CB

And then she mentioned *Anne of Green Gables*.

EB

Oh! She said they went to see it. They went to see it many years ago. But then I actually mentioned the whole kindred-spirit thing, and that actually made me laugh, when she told me—

CB

Oh, you did?

EB

—that story, because, "Oh, I'm sure that Miss What's-Her-Name's going to be a kindred spirit."

CB

Ohh!

EB & CB

(*Singing the tune from* Anne of Green Gables, *the musical.*) Kindred spirits!

CB

(*Singing.*) Just you and me!

They laugh.

CB

Uh—

EB

That's all I know.

CB

And, uh...yeah, she did say that. As soon as she met us, she did say that, pretty much. "You've found a kindred spirit."

EB

That was the first thing: "You found a kindred spirit! Would you like a cold drink?"

CB

Yeah, because she said, "Where are you going?" and we said, "We're walking to Canada." And then she said, "You've found a kindred spirit."

EB

I don't think she did. I think she actually...I don't think she said that. I think she...she came out and she goes, "Would you like a cold drink? I think you found a kindred spirit." You think—

CB

I—

EB

—you told her we were walking to Canada—

CB

I—

EB

I don't think you did that till we came inside.

CB

I th— I did it from the road.

EB

Oh!

CB

She, she said, "Where are you off to?" That was the— I think that was the first thing.

EB

Oh, I thought you said—

CB

She said— I said, "That looks like paradise!" And she said, "Where are you off to?" And—and I said, "We're actually walking to Canada!" And then she approached us, and she said, "You've found a kindred spirit!" And then she said—

EB

I don't think so, I, I think it went like this: I think you went and said, "Oh my gosh! You've— I've— Paradise!" And I think she came over and she said, "Would you like a cold drink?" And I don't—see, I—we hadn't told her anything about our hike until we went inside.[22]

CB

I'm...almost positive I yelled it from the road.

EB

And I'm almost positive you didn't.

Silence.

CB

That's really—

EB

'Cause then she finally said to me, she said to me, she said to me, "Where are you from?" And I said, "I'm Canadian." And she goes, "You're Canadian! How nice. That's why you guys are so nice and friendly." *(Laughs.)*

EB

Anyway, I don't know if that's actually proof of that fact, but I am quite certain she didn't. Anyway, interesting. I thought it went, "Oh my god!"—what did you say? Yeah—what a beautiful—what a paradise you have or something you said, right?

CB

I said, "What a paradise!"

The wind suddenly picks up.

EB

Right, so, and I thought she came over and said, "Would you like a, would you like a cold drink, would y—?" Oh my god, my passion flower!

CB

Is mine still in my hair? Yes.

EB

No—yeah it is.

CB

Yes, but I remember calling it from the road. This is why...I feel like I did it. Like, I remember...saying, "We're actually walking to Canada," because I remember feeling like, oh, I'm getting into a rhythm of, like, saying, "We're walking to Canada." Which, before, was not the first thing I'd say. But maybe I've totally invented the whole thing.

EB

Well—

CB

It feels clear to me.

EB

—you have said, "We're walking to Canada," twice today.

CB

Yeah?

EB

Which was the first time I think it happened ever. I said it once to the women at the van, or maybe we said it before, and then you said it to the people at the gro—at the ice cream store.

CB

Uh-huh. Uh-huh. Uh-huh.

EB

But that, yeah, anyway. It's interesting—

CB

Well. Myth. It's happening—

EB

And there's a big, big, black dark sky— Oh, what else, what else do you want to say about it?

CB

Oh!

EB

Anything else?

CB

Well, yeah, there was one thing that I really thought was so beautiful, was her...um...talking about how she just knew that this would be the last year that she would tend and cultivate this garden.

EB

No, no, no. She didn't say that. She said this would be the last garden she would have.

CB

Of the big garden.

EB

No, she just said this would be the last garden she would have. *Silence.*

EB

How did you interpret it? Go ahead.

CB

I interpreted it as...this— Well, I mean, I don't know, like, it could—I interpreted it—that, that would be one answer, but I didn't...nece— She said, "This is the last year I'll do a big garden."

EB

That's not what she said. Interesting, interesting. You keep going with what you thought she said.

CB ushers EB out the door. EB can still be heard (and sometimes seen) as she continues performing Christine's words in the Simultaneous Translation just outside. CB removes her headphones and makes a confession to the audience.

CB'S CONFESSION.

THIS CONFESSION IS A SECRET.

WHAT IS WRITTEN ON THE NEXT PAGE
WILL NEVER BE READ BY EB.

CB

Just want to say, having to listen to oneself is brutal. Torturous, in fact.

So, do you all still have some photos? This is the part I'm calling the confession.

None of these photos are mine. That's not entirely true—I took a few them. There are seven hundred of them—and maybe ten to twenty of them are mine, but the vast majority are Erin's. And, in fairness, she is a photographer. As you might have caught earlier, these photos were actually tricky for us on the road…a tangle. I gave Erin a lot of grief about them. We'd be walking along, there'd be a lovely twist in the road, or a bridge, or a swing set…and we'd have to stop, put down our poles, unbuckle and take off our backpacks; she'd reach deep into her bag and take out her camera…and this was not just whipping out your cellphone—it took time.

And something that started for me as a slight irritant eventually became a full-blown resentment.

I'd criticize her — "Can't you just enjoy looking at something without having to take a picture of it?" Or if I was feeling particularly holier-than-thou, I'd say, "You know, this is supposed to be a collaborative project." I made her self-conscious, uncomfortable

taking out her camera. I judged her.... and for a long time, I judged these photos.

But, in fact, if I am honest with myself...I was jealous. Jealous of the time and attention she would give to making these. Jealous that she had this way of seeing that gave her such pleasure. Jealous that she could make a story anywhere. And I was worried that these photos would become the only record of our walk, that her photos might actually become our memories. That I might not have something to add.

Part of this project is learning how to work together, but also to know each other, and I now know that Erin needed to make these photos. She needed an outlet, somewhere to put her unbelievable energy— walking seven hundred kilometres was not going to be enough. She needed to make something, in order for it have meaning. And in many ways, I believe she does this to survive. And perhaps survive walking seven hundred kilometres with me.

So, now I look at these photos and I love them. They are a record of our walk, but they are also a record of her incredible creativity, her relentlessness, her rigour, her drive...and they are also a record of my resistance.

After her confession, CB opens the door and EB re-enters, still speaking aloud what she hears in the headphones. CB puts her headphones back on and joins EB as they pick up on performing the Simultaneous Translation. Wherever it is still running in the track, it is still the same argument. They continue to play each other:

CB

—ach, what did she say... Oh, she said, "That's why I'm enjoying it so much, this year. Because I know it'll be the last time."

EB

She didn't say that either.

CB

She did!!

EB

No, not—not like that. I would have read that as something.

CB

Well, what did you remember her saying?

EB

Uh, I didn't remember her saying that.

CB

You, uh—"enjoying it so much?" Because I know she definitely said that. ⁓

EB

She could have—she probably said that, but I don't think she said the whole "last time." But anyway, I would— She might have, but if she did, I was standing there and I didn't hear it.

CB

Yeah.

EB

But.

The track is still playing, but finally they remove their headphones—placing them with their cellphones on the floor in the centre of the circle. They look at each other. They look at the audience. They shake their heads. They "give up."[3]
 CB repositions the chairs as EB stands and speaks, holding up a stack of kilometre markers for all to see.

EB

Now we are going to give some of you one of these kilometre markers. When we come to you, we would like very much for you to read what is on the back, in a big voice. You'll know when. If you do not wish to read it: no problem at all. Simply hand your card back to us and one of us will read it for you. If Christine is beside you, it is one of her journals; if I'm beside you, it's one of mine. Any questions?

As EB hands out the kilometre markers to audience members, CB sits and begins the Table Gestures—the choreography introduced briefly at the beginning of the show, consisting of a sequence of twenty-six physical actions paired with the names of individuals, spoken aloud, who hosted CB and EB along the walk. The gestures combine expressive postures with nuanced movements of the eyes, face, head, body, and hands; each is imbued with breath, and the sensory memory of a time and place shared with specific people. Each gesture is distinct in rhythm, tone, and energy, each capturing a memory of real sensation—not necessarily of actual events but of interpersonal experience. CB speaks the names of each host and performs the corresponding gesture while EB distributes the kilometre markers to audience members. When EB is finished her task, she sits down and joins CB. The two are facing one another, with an imagined table between them. They perform the entire list of names and gestures, this time in unison. They mirror each other while not attempting to look the same; in fact, inside each relative action, CB and EB convey their own unique lived experience.

EB/CB
Carolyn and Ralph
Linda
Anne
Hannah
Patricia and Elton
Albert and Mary
Linda
Rick and Pam
Pat
Marilyn and Dave
Tina and Rudy
Jennie
Mary-Anne
Don and Jeanette

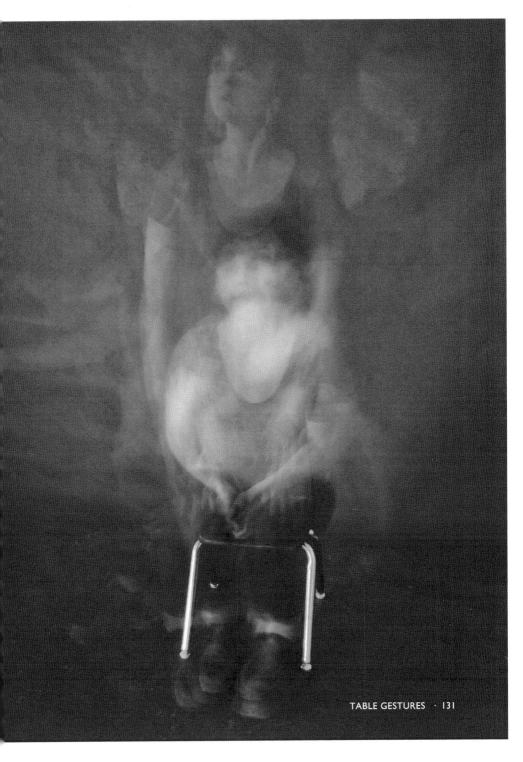

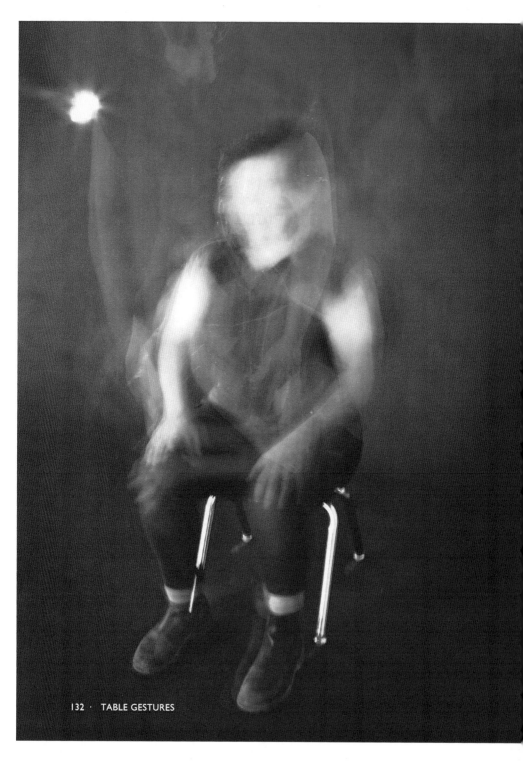

Amy and Jason
Matt and Patty
Laurel and John
Al
Jayne and Bill
Phil and Luanne
Joanna and Her Girlfriend
Jason
Karen
Grimsby Grandmas
Amanda and John
Paul's Friends

The Table Gestures sequence is repeated three times in total, and with each repetition the tempo accelerates. The final set is performed at peak speed; CB and EB push each other forward, attempting to stay in sync and to end in unison. When they finish, they race to the 0 kilometre marker and begin to read the following journals, progressing around the circle and sticking each kilometre marker to a visible surface in the room as each card is read, completing the "map" of their journey around the room.

CB

0 km. The lights are so low, the streets so small. It's dark. I don't know this flavour, this culture.

EB

17 km. Feels so wild to travel through and know you aren't coming back this way.

CB

38 km. The first two rules we came up with were about Facebook and how we will use it. I hate rules.

EB

38 km. Trying to figure out what rules are necessary. We spent way too much time talking about how to and not to use FaceBook. But then we agreed, and I was relieved to have decided.

CB

38 km. We talked about it for miles and miles and miles. We lost our minds a bit but pushed through.

EB

38 km. Christine was angry about being blessed by people with questionable politics. I'm not sure how I feel about being blessed in general.

CB

61 km. Why do people tell the same stories over and over again? Why do we tell the same stories over and over and over again—about ourselves?

EB

61 km. We stopped at a post office in the middle of nowhere and a man came in and offered us water. He was kind to us, but also a bigot. I had the understanding that I only felt safe doing this because I am white.

CB

61 km. So, so tired. No coffee for too long. Felt sullen and dark and not sure why this is a good idea.

EB

87 km. We love Harrisburg. Versions of ourselves would like to pick up and start lives here.

CB

103 km. Halifax is an ugly, mean town.

EB

103 km. I saw a sign on a house that read: *No soliciting. Please go away. We have found Jesus.*

CB

103 km. So much was boarded up. And what was going on with that pool? No one in it in the dead of summer.

CB

137 km. Longest walk yet. Feeling it. It was beautiful for a while, and then really tedious. We didn't have a fucking map. Met folks tonight walking all two thousand-plus miles of the Appalachian Trail.

EB

137 km. It was really great today to be with people who thought what we were doing was totally unremarkable. They have been walking for months. We've been at it for less than a week.

CB

137 km. One woman talking about how you're alone all the time. And then there was another woman who told us, "You're never really alone."

EB stops reading her journal entries and looks at the audience.

EB

Now, if you're holding a kilometre marker, would you please hold it up where we can see it? Thank you.

The kilometre markers between 164 km and 325 km are read by audience members. During this sequence, EB and CB continue their "journey" by standing behind each audience member who has a card and cueing that person to read aloud.[24]

AUDIENCE MEMBER 1 FOR EB

164 km. She asked us if we wanted to join her by the fire. When I got outside, I saw that she was burning the dozens of plastic water and Coke bottles they consume in a day. I tried to ask her how often she sat by the fire like this and gently say I was worried about her health. She showed me where she was growing weed and made me promise not to tell her husband.

AUDIENCE MEMBER 2 FOR CB

186 km. I'm homesick today. Wish I was there to help with camp drop-offs, lunches, driving Ruby to gym. I wonder why I am here, what I am making, what this has to do with my life at all. I'm not sure how generous I am.

AUDIENCE MEMBER 3 FOR EB

205 km. I thought about the ways we are already performing family: so easy and uninhibited—but also fearful of judgment and easily wounded.

AUDIENCE MEMBER 4 FOR CB

209 km. I want to scream just *settle down*. I miss my husband's gentleness.

AUDIENCE MEMBER 5 FOR EB

209 km. I wonder if, on some level in the evolutionary scheme, sex exists so that folks can communicate when they are at an impasse.

AUDIENCE MEMBER 6 FOR CB

234 km. Erin is anxious about her skin. She is always itchy.

AUDIENCE MEMBER 7 FOR EB

234 km. CB is moving in the morning—wants to get going, keeps me on task. Takes care of things. I keep us energized at the end of the day.

AUDIENCE MEMBER 8 FOR CB

234 km. I felt strong for the first time.

AUDIENCE MEMBER 9 FOR EB

255 km. Things are feeling safer. We are laughing at ourselves.

AUDIENCE MEMBER 10 FOR CB

255 km. Sweaty and overcast. Still following the Susquehanna River, which we can see on our left occasionally.

AUDIENCE MEMBER 11 FOR EB

279 km. Today: trains, trucks, and snapdragons. On arrival, I was so frustrated with CB, and then we arrived and laughed—and she said we needed ice "for our feet" and we brought it into the quilted room and poured hot beers in clandestine cups with the door closed.

AUDIENCE MEMBER 12 FOR CB

279 km. Interesting to hear him talk about the cows. I have some strong negative feelings—so much darkness in the beef industry. But then I look at them and their eighty-year-old healthy selves and they live modestly and they're happy...and maybe I'm a little jealous.

AUDIENCE MEMBER 13 FOR EB

301 km. Standing up in the morning is hard.[25]

AUDIENCE MEMBER 14 FOR CB

301 km. We are so hot. I just want to get there, but Erin encourages me to jump in the river. I resist at first, but I am so glad we did. I want to be more like her. Not hold back, be generous.

AUDIENCE MEMBER 15 FOR EB

301 km. I set it up wrong, because I'm on a terrible angle, but it is too dark out, and I am too tired to get up and fix it. I'm now in a ball at the bottom of the hammock.

AUDIENCE MEMBER 16 FOR CB

325 km. It was hot today. Erin amused me with a play-by-play of the movie *Beaches*.[26] It actually worked. Killed an hour at least. It made me laugh. In Arnot, we were hoping for beer, but the church restaurant people were unfriendly. All anyone talked about were bears. I was frightened. Everyone told us we couldn't camp, so that's why we're in Wellsboro a day early. Lots more happened, including Erin wielding her charms and scoring us a lift. She's cranky because it felt like cheating, but I'm happy to be in such a comfortable bed.

AUDIENCE MEMBER 17 FOR EB

325 km. I felt fragile and cranky and was trying to parse it out, so I went to a movie by myself in Wellsboro tonight.

EB and CB resume reading their own journal entries on the kilometre markers.

CB

356 km. Virtuosity, adventure, what it means to move—how fast it takes. What draws us to another person, risk, how lazy and fat we've become, trapped in our routines, getting attention—connecting with a community that will include me, makes me family just because of my name.

EB

356 km. Comfort and discomfort; taking time; patience; the body—
what it can do/needs, actually feeling it; doing something difficult;
memory; STORIES—what people need to tell—kindness and conflict;
how people can be together.

EB

375 km. It's 7:00 a.m., the time we always wake up now.

CB

400 km. I think about my dad a lot. I think about my mom
about...half as much time, I guess. She died when I was eighteen;
my dad died when I was thirty-six. Twice as much time for his
world and his way of being to impact me.

EB

426 km. She likes to read us our "Free Will Astrology." Today, mine
said that I should be *a benevolent mischief maker* and she *a burden
sharer*. She thought this was an unfair role distribution.

CB

460 km. I find myself resisting a desire to package it up and make it
into something. I just want to say, "*Stop, wait—stop, stop, stop.*"

EB

460 km. She's always accusing me of collecting and crafting. We never
really agreed on the subject of documentation and so now we're inside
the thing just sort of following our own impulses within the bounds of
not doing something that the other person opposes. It's true, I'd love
to craft the story of the experience together. But she would like to *not*
craft it from the inside, and so we both water our impulses.

CB

483 km. We walked and talked it out for a long while, maybe five miles? It was good. Tricky business—but we've agreed to clean the slate. Start fresh.

EB

510 km.27 Crossed the border to New York State yesterday. Someone said it was only a four-hour drive to Ontario. We still have two weeks to go.

CB

542 km. I am so close to home. I'm wondering again why I'm away from my kids. I've secretly begun to pray, wanting to lean on someone.

EB

570 km. I'm mostly just tired from being "on" all the time. It is a lot of energy in addition to the walking.

CB

600 km. Gratitude is a fucking slippery slope.

EB

635 km. Waiting for CB after a nine-and-a-half-hour walk. I changed in the bathroom and put on some lipstick. I know she'll make a comment about it. I love this town; it has its own font.

CB

656 km. We crossed the border to Canada today. We massaged each other's feet.

EB

656 km. Crossing the border was sort of anticlimactic.

CB

656 km. Strip malls and highways. Nothing exotic.

EB

685 km. CB collects butterfly wings from along the road and puts them in her journal. I spot them for her because she never wears her glasses.

CB

700 km. We were greeted at the Brubacher House in Waterloo with a welcoming hymn. I cried.

EB

700 km. I was too overwhelmed to know what I was feeling.

If you still have a photo, we'll collect it now.

EB and CB each collect an equal number of the remaining photos from the audience and approach the document camera. They take turns putting photos down one at a time and improvise a single descriptive line about each one.[28] *The descriptions begin as factual statements about what is depicted in each photo. Slowly, as more photographs are shown, the descriptions become a bit more whimsical—feelings or concepts, but still related to the given image. As CB and EB get to the final few photographs, they attribute incongruous moments from their own lives to the image in the photo.*

The following is a transcript from the performance on Friday, December 1, 2017, at the Emmet Ray in Toronto.

EB

This is the youngest vegetable grower we ever met.

CB

This is one of hundreds and hundreds of farm-field vistas.

EB

This is a sign that you can have your own of, if you call the number on the side.

CB

This an air-conditioned laundromat.

EB

This is the woman whose garden we argued about.

CB

This is one of many bodies of water.

EB

This is the place where they burned their garbage.

CB
This is a cemetery where our ancestors are buried.

EB

This is when we had to go back.

CB

This is a shadow in the town of Angelica, which is the birthplace of the Republican Party.

EB

This is Christine's feeling of disgust.

CB

This is a generous moment where I posed for my friend.

EB

This is a place I didn't want to leave.

CB

This is another photo opportunity.

EB

This was some time I took by myself.

CB
This is a moment when I felt conflicted.

EB

This is a really kind offer.

CB

This is the buildup to decades of disciplined practice.

EB

This is my recurring dream.

CB
This is where I fell off my bike.

EB

This is the first time a teacher scolded me.

CB
This is my oldest T-shirt.

EB

This is where I fell in love.

CB

This is where my tooth fell out.

EB

This is where I had my first sleepover.

CB
This is my grandfather's watch.

EB

This is my favourite park.

CB

This is a brick from my house.

EB

This *is* a brick from my house.

END

ENDNOTES, or,
A TALKBACK WITH DIRECTORS
CHRISTOPHER STANTON AND ANDREA NANN

1 AN: Each time the show has been performed, the distinct space is not transformed but rather the venue transforms the design for the piece. Our designer, KH, reflected that when EB and CB were walking, they carried everything they needed with them, day to day, kilometre to kilometre. They set up their personal belongings in each new place, homes foreign to them. When they perform the piece, they also carry the objects needed for our journey. The performance objects we continue to carry with us make the stories feel at home wherever we are.

2 CS: This little phrase—"Okay. Well."—gets repeated often in the text. It's a simple thing, but it works as an invitation to lean in and listen up—we're about to tell a tale. (cf. Seamus Heaney's notes on his translation of *Beowulf*, and its very first word: "So.")

3 CS: Nearly everything is different with every performance, of course. But to my memory, this line was always the first shared laugh for the audience. It was always a nice, warm thing to hear.

4 AN: This is, like, the physical, or movement equivalent of "Okay. Well."

5 AN: The Table Gestures are a series of nuanced physical expressions that summon Christine's and Erin's personal feelings as they shared "every meal with people, new people all the time." (Interpretations of movement in the Table Gestures can be seen in Sam Choisy's photographs on pages 131 and 132 of this book.)

6 CS: Erin always uses this moment to kibbitz a bit with the audience, with Christine often chiming in from her position at the document table. It helps to put the room at ease, making sure everyone feels taken care of. (Personally, I think it's important the audience is clear early on that the show will not feature audience participation in that awful, gently humiliating, fake grin-and-bear-it way that always makes me want to crawl under my seat.)

7 AN: Up until this point, CB and EB have presented themselves as a pair, a twosome. A duo. The Photo Game is the first time we hear memories that are unique to each of them.

8 cs: Over the course of our many performances, we got a few little "Easter eggs" like this one, where we get to hear the same story from each performer's perspective on different nights.

9 an: Early in our process, cs divided the performance area into "hemispheres." During the Photo Game, eb and cb move apart—eventually migrating to separate hemispheres for the Story About the Brick and the Story About the House. As the performance progresses, this mapping of the space becomes a much-used device.

10 an: Here, eb extends her gestures to evoke the kind of kinesthetic memory or sensory recalling that the Elder Mennonites may have used to reconstruct Brubacher House.

11 an: The Journey Gestures are illustrative, perception-based, physical metaphors. In this way, the Journey Gestures serve as a kind of live "body mapping," attributing a symbolic depiction in the form of physicalized actions, to indicate important landmarks or revelations along the journey. The performers' gaze serves as a zoom lens, narrowing to focus on something immediate or close-up, or widening to expand meaning from something specific to something universal. These five spoken lines and the corresponding Journey Gestures are performed here to mark the moment that Erin and Christine made the decision to create something together. Each of these lines is extracted from existing text (including dialogue spoken during Simultaneous Translations). The first couple of lines are very concrete. The lines that follow remind us that we can also experience this journey allegorically. This is the only time in the performance that the spoken lines and Journey Gestures are performed as a set. Single Journey Gestures are sprinkled throughout the performance. (The Journey Gestures are represented by photographer Sam Cho^isy at the beginning of this book.)

12 cs: As fate would have it, I was also at this party.
 an: I'm pretty sure I was at a party just down the road that same night!

13 cs: In the fall of 2015, having been asked by Christine and Erin to collaborate with them on this project, I attended an early workshop reading of *7th Cousins*. The reading was composed from material collected while on their journey together—personal journals, texts, etc.—but mostly from transcriptions of bits of audio they recorded on their phones while they walked. I was fascinated by how to approach these audio transcriptions. In an email with the subject line *Thoughts* I wrote to them shortly after the reading, I offered this unhelpful nugget: "How on earth do you stage this?" A couple months later, we got into a room together and started looking at exactly that question. We all felt that

performing the transcriptions as "characters" in scenes wasn't right. It allowed Erin and Christine to curate their own personalities through performance. To smooth the edges—the disagreements, the irritation, the interruptions, the non sequiturs—that were so beautifully present in the raw recordings. So we came up with Simultaneous Translations. I gave each performer the task of listening to the original audio track on her own set of headphones. They would start the track together (Make eye contact! One! Two! *Three!*), and then each performer would say her own words *as she heard them*. The task was a mechanical one: match the intonation of your voice but do not *emote*. Don't act. Just say the words. Make space for the audience to fill in the rest. It's really hard to do—try it!—and that helps the performers to stay out of their own way. And that's ultimately how we performed the audio. The results were surprising, deeply human, and often really, really funny. And, like magic, we were able to hear the words as though it was fresh. It allowed for the performers to remain surprised by the material, while maintaining the lack of polish in the source material. But even more, for me, the Simultaneous Translations became symbolic of the walk itself. Two women, alone, together, experiencing the same thing in slightly different ways. Working through a difficult task: no script, no map, in the moment, and in the wild.

14 CS: For some reason I can't quite articulate, I refused to follow my impulse to research or fact-check any of what EB is talking about here. I think I was worried that if I knew the "real" story, it might rob me of the delight in hearing her try to confidently describe a thing she's so uncertain about. I still have no idea how accurate her take on "the Princes of Serendip" is. But you should feel empowered to pick up Erin's serendipity research where she left off.

15 CS: This part is a ton of fun to watch and hear. Yet I always found the effect of this messy, kinetic torrent of family history really moving. So many lives spanning what seems like such a long time, each life distilled to fit on the back of a postcard.
AN: Super-fun. At the end of this frenetic game, the "winner" is awarded a moment to gloat, and the audience participants, who took on the Brubaker/Brubacher/Bruppacher name tags, are always rewarded with applause from everyone else.

16 CS: KH designed the kilometre markers to evoke U.S. and Canadian highway road signs. Fittingly, the font is called Highway Gothic. I half-remember an observation I made during childhood trips to the States: road signs in Canada are green, while in the U.S. they're blue. So this was the convention we used for the markers. Turns out this was a bit of graphic-design mythmaking on my part. Lots of green signs in the States, lots of blue in Canada.

17 cs: On August 11 and 12, 2017, a rally organized by white supremacists took place in Emancipation Park in Charlottesville, N.C. The rally was in part a reaction to the proposed removal of a statue of Confederate general Robert E. Lee. At the rally, a man—one of the white supremacists—drove his minivan directly into a crowd of people who were peacefully counter-protesting. He killed thirty-two-year-old Heather Heyer and injured nineteen others. He was found guilty in December 2018 and sentenced to life in prison. At the time of publication, the statue has not been removed.

18 cs: Neither cb nor eb remember many specifics about this book. It was a paperback. It was "full of hateful things." It was "super-homophobic and about Disney somehow." It was "some argument about the evil world cloaked in creepy god language." They had read some of it in the rooming house where they stayed the night before, having randomly picked it out of a handful of books on a bookshelf meant for guests. They took it with them, carrying it for quite a while before actually throwing it out just before (or just after) this conversation took place.

19 cs: Sometimes, in a moment of conspiratorial mischief with the audience, eb would sigh with relief and smile just after cb had exited the room. Then the confession would begin.

20 cs: This is the first time the audience hears an actual recording from the road, played through the loudspeakers.

21 an: An episode of the hbo series for Margaret Atwood's *The Handmaid's Tale,* featuring a handmaid suicide bomber, had recently aired. eb talked about the disconnect between her adherence to Mennonite pacifism and her gut response to root for the suicide bomber—raising the most extreme questions about when you fight for what you believe in or for a pure sense of right and wrong.

22 cs: It was always a highlight watching eb and cb visibly pained as they were forced to recreate this disagreement in real time.

23 cs: We could often hear their voices continuing (ad infinitum?) out of the discarded headphones. This track is particularly painful/hilarious to listen to, and it goes on *forever*. It's a classic cb/eb road argument—increasing and multiplying fractals of disagreement. Arguments folded into other arguments. They called it *the Vortex*. (It's possible we occasionally entered the Vortex while making the show.) Countervailing Memories + Recollection of Events = Total Vortex.

24 AN: This sequence always amazes me—how audience members, strangers mostly, dive into reading these passages as if they were their own lived experiences. Fatigue, irritation, heart, and vulnerability seem true. Sensations, frustrations, betrayals—real.

25 CS: Audience-participation highlight: a woman in Kitchener–Waterloo made a point of having a *really* hard time standing up before she read this card to the room. Pretty delightful.

26 CS: Early versions of the performance included EB actually doing a bit of this. It is troubling to me how detailed her recall of this film is. She really could describe the whole goddamn thing.

27 CS: This was where the U.S. blue kilometre markers became Canada green, even though the border CB/EB cross here is New York State, not Canada. It's a little mistake that stayed in.
AN: Okay, now that it's out, I have to admit, as a Virgo, the change to green here has *always* puzzled me...

28 CS: The intended arc of this final section is difficult to capture every performance—or, really, to clearly define in words. It's a three-part structure: improvised factual statements about what is depicted in each photo, then whimsical feelings or concepts related to the given image, and, finally, incongruous moments from their own lives attributed to the image in the photo, essentially creating a palimpsest—we are making a conscious choice to build a new personal mythology over existing memories. All improvised. Not an easy task. But they very, very often made it work. And when it works it is sublime.

ON HOSTING AND GUESTING

When we first started working together, EB proposed a concept for our project that she called Hosting and Guesting, a framework for thinking about performance. One of our first explorations, pre-walk, was something we called Brubach/ker Family Dinner, where we invited twenty people to a meal at CB's home in Toronto in December 2014. In this performance, we cast our audience as "guests" and ourselves, the performers, as "hosts." But we hadn't anticipated the way these roles would be reversed on the walk: we didn't really consider what it would be like to be hosted by all these people, these many souls who opened their homes to us. We had thought about what it might be like to be together, the two of us; about the virtuosity of pushing ourselves physically, carrying all our possessions on our backs; and we spent a considerable amount of time talking about the act of walking itself, in all kinds of ways— in relationship to time, distance, the body, and as a way to be together... But on day one of the walk, neither of us had any idea the relationship between Hosting and Guesting would be so central to what we were making. We had no idea about the impact, the daily dynamic of Us and Them, and the sheer energy of having to be "on" every night with new people, some of whom we had very little common ground with and seemingly very divergent values.

To this day, we are still trying to understand why these people took us into their homes. Only a very few of our hosts were actually listed in *Mennonite Your Way* (the paper directory for travelling Mennos). Most came from rhizomatic connections to the directory:

neighbours, people from their church, friends of friends. Some were delighted to have us there. They were friendly, open... Others, not so much. Was it about curiosity? Obligation? Isolation? We walked through many very small towns—literally only a handful of houses—where people don't often meet people who come from outside.

Each evening, we sat at a new table, shared a meal, communed with some new hearts. You'd think they'd have been curious about who we were and what we were doing, but strangely, we more often found ourselves learning about their lives. It felt like they asserted their values from a place of needing to be heard. Looking back, we wonder if they needed a vessel for their stories.

We wonder too if our relationship, what we were doing together as two women, was so strange and foreign that they implicitly needed to give us the "lay of their land"—their "world view"—in order to feel comfortable with us under their roofs. Our relationship and what we were working on was so outside of their experience, we often felt them grasping for boxes to put us in. CB had easy points of (heteronormative) connection—kids and a husband— for them to make sense of her world. To categorize EB, they would sometimes infantilize her, make her younger and "not yet married," casting CB as EB's older sister/mother type. Our urban Canadianness became uncomfortably evident when we communed with folks from the conservative American Bible Belt. There was a nightly dance we would do, trying to suss out the "house rules" over meals and through conversation, feeling out the ways in which we were or weren't welcomed. Hosting and Guesting became a framework for unpacking all sorts of questions about what we were and weren't allowed to talk about, what we should and shouldn't

say, and the impasse that would sometimes arise between values or beliefs, and generosity or grace.

Our only explicit reference to Hosting and Guesting inside the performance text is when we tell the story about the Baptist Pastor's Wife. In intentional encounters with strangers, there is often this inherent desire to be able to say, "Oh, it was so great! We met these wonderful people! It was so meaningful!" Not everything is like that. On the walk, we met people we loved and we met people we never wanted to see again. But the people who stayed with us most strongly were the ones about whom we felt dissonance: a real sense of warmth and care mixed with unease and complicated feelings... sometimes a kind of love and outrage at the same time.

After the durational performance of the walk, we made the show that is documented in this book. Performing this show has been yet another exploration of Hosting and Guesting. To share this work with audiences, we have been guests in many different and divergent spaces: a United Christian church, a Royal Canadian Legion, an Ismaili Muslim cultural centre, a Mennonite chapel, a local bar... all places where we have been hosted and had to negotiate "house rules." We allowed our work to change and evolve based on what happened in these spaces and grew our commitment to being on a journey. One of the journal entries in the show is: "It's so wild to travel through and know you aren't coming back this way." By moving from non-theatre venue to venue, it's like we're back on the walk—Guests in every venue, Hosts to every audience.

Something about being both a Host and Guest keeps our show alive and fresh and vulnerable. It keeps us returning to the walk

and to the love and frustration we find in each other. This "we decided we would be family" thing continues. Hosting and Guesting helps us resist getting cozy, or comfortable or complacent. It keeps us on our toes. Because if we got too cozy inside the performance, we think it might kill it; we wouldn't be on the walk anymore. And the endurance of the walk was not the walking. It was being with other people and being with each other.

—CB & EB, December 2018

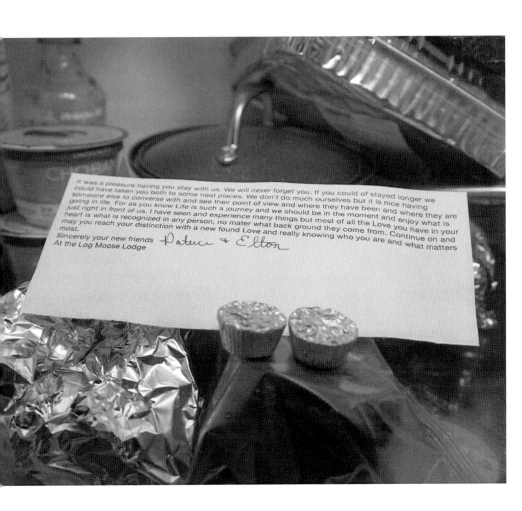

It was a pleasure having you stay with us. We will never forget you. If you could of stayed longer we could have taken you both to some neat places. We don't do much ourselves but it is nice having someone else to converse with and see their point of view and where they have been and where they are going in life. For as you know Life is such a journey and we should be in the moment and enjoy what is just right in front of us. I have seen and experience many things but most of all the Love you have in your heart is what is recognized in any person, no mater what back ground they come from. Continue on and may you reach your distinction with a new found Love and really knowing who you are and what matters most.

Sincerely your new friends *Patrice & Elton*
At the Log Moose Lodge

TIME, a postlude

Exactly two years after the walk, in the summer of 2017, we got in
the car and drove back to Pennsylvania. We drove across the thirty-
two days in under eight hours. Sometimes, in the span of fifteen
minutes, we'd watch out the window as another day of our past life
flew by. We were on our way to perform excerpts of what would
become *7th Cousins* at a "family reunion"—a gathering of over five
hundred Brubakers and Brubachers. Mennonites are known for
being passionate about genealogy, and it is surprisingly common to
gather a crowd of relations. Afterwards, we planned to use this
opportunity to make a new, one-time-only performance during the
car ride home for the SummerWorks Performance Festival in
Toronto. We would drive all day, directly to the performance site,
where the festival audience would be waiting in a parking lot to
welcome us. Our performance was called *The Unpacking* and it
became another experiment as part of the making of this whole. It
unfolded as a retracing, in reverse, of the journey we had made two
years earlier, an interrogation of our beliefs, views, and memories
from our current points of view, and the discovery of what had
changed since the walk, in us and in the us.

The relative speed of *this* journey was terrifying. The entirety of
it took less than a weekend to drive, perform, turn around, drive
back, and perform again. More condensed than the walk, but as
overwhelming, for different reasons—anticipated and
unanticipated. One of the biggest changes was the new president.
Donald Trump had been elected eight months earlier. Our walk

had taken place during the end of the Obama era, and though we met few Obama fans in 2015, the inhabitants of the rural terrain we were travelling (Pennsylvania: one of Trump's election battleground states) had participated in this epic regime change, and the atmosphere most certainly felt different. *Make America Great* signs decorated barns and buildings, Confederate flags flew more freely, and, most overt and most deeply disturbing, in the small town of the Baptist Pastor's Wife, we came upon a property brazenly adorned with lit-up swastikas and dozens of Nazi flags— amongst them a sign that read, *Help our president take out the trash.* We turned the car around, pulled over to the side of the road, and sat looking out the windows, mouths agape. On the way back two days later, we knocked on the Baptist family's door to say hello and dig up the courage to ask about their Nazi neighbours. "How is this blatant racism breeding in your tiny town?" The Baptist Pastor had referred to God as "my boss." We wanted to know what his boss thought about it. His response included something like "Well, our kids play on the same soccer team...you know?" and "He's lived in this town even longer than us..." The pastor said he tried to reach out to his neighbour from a ministerial point of view, and was offering marital counselling to the parent-couple...He too was trying to make sense of it, but the tension was taking a toll. We asked, with less delicacy than we had employed with our hosts on the walk, how he reconciled that hateful output in proximity to his adopted children, the only black kids for miles. He said, "You know, some European TV crew came in here and filmed it—I saw the clips on the internet and I read the comments...People were saying [my neighbour] should be shot. How's that any better than what he's doing?" We felt shocked by the degree to which things seemed to have changed since we had walked through that town,

and also knew that what we were witnessing had always been there, waiting for permission to live on the surface. Still, we wondered if we would have walked that path after Trump had been elected. If we had, we would have approached it very differently. We're pretty sure the global narrative of "America" would have hijacked the whole journey.

Truthfully, we were both a little allergic to the idea of celebrating three hundred years of Brubakers/Brubachers in North America—the theme of the 2017 reunion. For them it was, in large part, a commemoration of a small, historically tight-knit community escaping a long history of persecution for pacifism. From our perspective, the idea of celebrating a bunch of white settlers in any context felt pretty uncomfortable. This lens was unknown to most of the Americans attending the reunion. When, at the beginning of our performance excerpt, we talked about the land and the people who had come before us, no one knew what we were doing. (They certainly didn't understand our use of the word *Indigenous*—in that part of the United States, both Indigenous and non-Indigenous often use the term *Indian* or *American Indian*. Sometimes *Native American*.) There were exceptions: one Brubaker/Brubacher, a minister who had been invited to speak at the reunion's Sunday service, delivered a sermon about the arrival of the Mennonites in Pennsylvania and how William Penn's "holy experiment" which brought them there turned out to be anything but holy for the Conestogas of Lancaster County (the original caretakers of the land). She concluded by asking how we might, through our actions, demonstrate genuine apology. She said it was our responsibility to remember that the past from which we benefited was catastrophic for the Indigenous peoples. She asked us to imagine the land as it would have been when our ancestors first arrived and to imagine

what might have been if Penn's "holy experiment" had been holy for everyone. She said that the weekend we had just spent together had taught us more about how we've been shaped by the decisions our ancestors made and asked us how future generations, in the next three hundred years, will be impacted by our present action or inaction. This Brubaker's sermon was juxtaposed with another Brubaker minister's delivery of a fire-and-brimstone text with what we perceived as a fair amount of fear-mongering. The audience, or congregation, seemed equally open to both addresses. Just as they seemed equally open to all the Brubakers/Brubachers "of note" who gave presentations throughout the weekend—from a Republican state senator to a pair of lefty artists from Toronto. It was kind of incredible to be in the company of so many people whose views and beliefs were so drastically different, but who were ready to receive each other—based on no more or less than a shared name. After our performance, one woman, who had been in attendance with a pack of twelve children, ran after Erin to ask why we had used the word *actor* rather than *actress* in reference to ourselves. "Aren't you proud of being women?" she asked. We had a long talk about everything from not having terms like *doctoress* or *lawyeress* to Christine being away from her children while on the walk. Erin talked about what she saw as the inspiring example Christine was setting for her daughter. (At the time this was just theoretical for Erin, and now she too has kids in her life who would have completely changed her sense of being on the walk...Another marker of time.) At the end of the talk, the woman said, "I don't share your views but I was interested to hear them. Thank you for taking the time to talk." We swam through so many muddy waters of *being with* other people that weekend—and, as usual, with each other too. Many debates in the car, Erin making assumptions about our American cousins on

the way there, and Christine calling Erin on those assumptions, and talking about being both right and wrong on the way back.

On our return, in fact, there was no real time to digest or *unpack*; we just had to be there, accountable to the present moment, to each other, to that one-time audience, and to our experiences with other people in the preceding days.

Following the SummerWorks performance of *The Unpacking*, Erin reached out to some Brubaker/Brubacher reunion leaders about changing the language on their website, the header for which read: *Securing and Promoting Brubaker Family History and Heritage.* "The language of 'securing the history' of white settlers feels scary to me in our times," she wrote in an email. "I know it isn't meant this way, but I think we could do better." For some of the "kin" she reached out to, the suggestion of acknowledging how Mennonites benefited from wrongs of the past created discomfort and resistance, like the "cousin" who had also told us he "*had* to hold my nose and vote for Trump." Others were immediately on board, including another Canadian Brubaker/Brubacher who had given a lecture about refugees and how the act of remembering the past can shape the future. In his talk, he asked if our Mennonite experience as a persecuted and migratory people had shaped who we are as a compassionate community. He wanted to know our own history of being refugees was sufficiently in our bones to have compassion for the strangers who appear at our gates today. After three months of corresponding with the more senior Brubakers/Brubachers with whom we had found common ground at the reunion, we collectively convinced the webmasters of the *Brubaker Families of America* website (and the organizers of the annual reunion) with whom we had less vocabulary and ideology in common to change the title mandate of the association to *Remembering and Sharing Brubaker Family History and Heritage.* Perhaps a small thing in the big picture, but a significant lens shift for a group of people.

Now we're unpacking this all and more in the ongoing journey of our automythography—another two years later. At a time when interpretation of events and what are actual *facts* is under attack, and when *alternative facts* and *fake news are* terms leveraged for political gain at the world's peril, we are wondering about our use of the term *automythography.* Surely it's just another version of interpretation in a particular time and place. For us, it's about naming the way our current understandings shape our memories and our way of seeing the past.

A book is a time capsule that you hope, with crossed fingers, holds up. A performance is always accountable to its live present. It is hard to say which is scarier.

—EB & CB, July 2019

ACKNOWLEDGEMENTS

7th Cousins was made to be performed in different community meeting places. After a test run in CB's Parkdale living room, *7th Cousins* was first presented by Nightwood Theatre in Toronto at the Royal Canadian Legion Branch 344, St. Matthew's United Church, the Emmet Ray bar, and the Ismaili Centre. In its first year of production, it was also presented by Green Light Arts in Kitchener–Waterloo, Ontario, at the Conrad Grebel Chapel.

We have ongoing appreciation for all the people who, in various ways, hosted us on our seven-hundred-kilometre walk: Carolyn and Ralph, Linda, Anne, Hannah, Patricia and Elton, Albert and Mary, Linda, Rick and Pam, Pat, Marilyn and Dave, Tina and Rudy, Jenny, Mary-Anne, Don and Jeanette, Amy and Jason, Matt and Patty, Laurel and John, Al, Jane and Bill, Phil and Luanne, Joanna and Rachel, Jason, Karen, the Grimsby Grandmas, Amanda and John, and Susan.

Samantha Gignac was with us for *7th Cousins* at the Royal Canadian Legion and co-designed sound for the show alongside director Christopher Stanton. Simon Rabyniuk helped us in our thinking about this work along the way. Megan Macdonald, Ian Willms and Samuel Choisy provided some outside eyes for aspects of this project as it neared publication. Robert Plitt and Richard Lachman are invaluably in our corners as we make things.

Thank you to Hazel and Jay at Book*hug for encouraging us to translate performance to the page.

We would also like to express gratitude to those who believed in what we were pursuing and supported the early development of this work:

Pat The Dog, The Blyth Festival, Theatre Gargantua, Festival Players, Summerworks and Common Boots all financially supported the walk through the Ontario Arts Council Theatre Creators' Reserve. Mark Brubacher offered countless materials and resources about Mennonite history that provided a context and foundation from which to explore other things. Lyane, Theresa, Sheila, Martin, Stewart, Nancy and Brian, Penny, Elizabeth, Brenda, Barbara, Sue and Joan all helped finance the first workshop phases for this project in spaces donated by Tarragon Theatre and the Theatre Centre. Summerworks Performance Festival gave us the opportunity to experiment with onetime performances that shaped our overall project—in particular Cathy Gordon and Laura Nanni made space for us to take risks. Kelly Thornton and Beth Brown championed *7th Cousins* through Nightwood Theatre to help realize its first full production, which was supported by the Ontario Arts Council and the Canada Council for the Arts.

CHRISTINE BRUBAKER is a director, actor, dramaturg and educator. She is the winner of two Dora Mavor Moore Awards for Performance, the 2014 Gina Wilkinson Prize for Direction, and the 2016 Ken McDougall Award for Emerging Director. She directed the world premieres of *The Horse and His Boy* and *Wilde Tales* (Shaw Festival), Elena/Eli Belyea's *Smoke* (Downstage Theatre), *Elle* (Theatre Passe Muraille), and the Canadian workshop premiere of Suzanna Fournier's *antigone lives**. Christine is the creator of *Henry G20*, a large-scale outdoor performance and contemporary adaptation of *Henry V* that speaks to global capitalism and the protest movement premiering at the Luminato Festival in 2020. She is on faculty at University of Calgary's School of Creative and Performing Arts. She holds an MFA in Interdisciplinary Arts, is an alumnus of the National Theatre School and the Michael Langham Program for Classical Direction at the Stratford Festival.

ERIN BRUBACHER is a multidisciplinary artist. Her work has taken her across Canada to venues such as The National Arts Centre (Ottawa), The PuSh International Performing Arts Festival (Vancouver) and The Aga Khan Museum (Toronto), and internationally to Scotland, France, The Netherlands, Germany, Mexico and the USA. As a theatre director, Erin works with writers, performers, musicians, choreographers, visual artists, and other makers to collaboratively create new works including the award winning productions of *Concord Floral* (Brubacher/Spooner/Tannahill) and *Kiinalik: These Sharp Tools* (Buddies in Bad Times Theatre). Erin found her artistic foundation in photography at Mount Allison University and holds a practice based MA in International Performance Research, jointly from the University of Warwick and University of Amsterdam. She is the author of the poetry collection, *In the Small Hours* (2016) and a new work of fiction forthcoming with Book*hug.

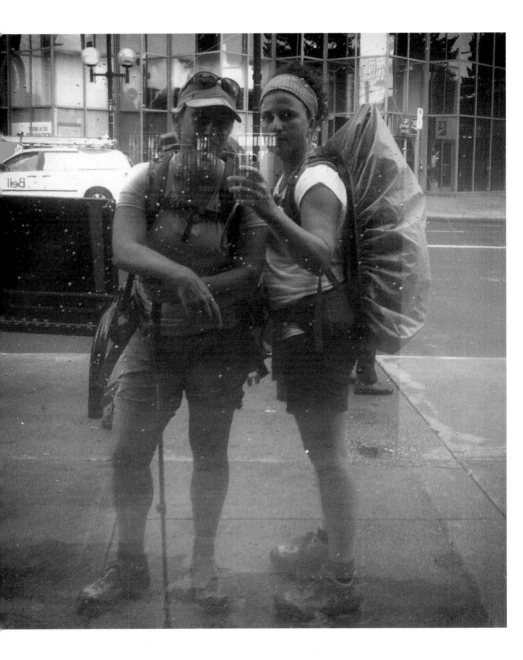

Manufactured as the first edition of
7th Cousins: An Automythography
in the fall of 2019 by Book*hug Press

Copy edited by Stuart Ross

bookhugpress.ca